CLEVELAND BROWNS HISTORY

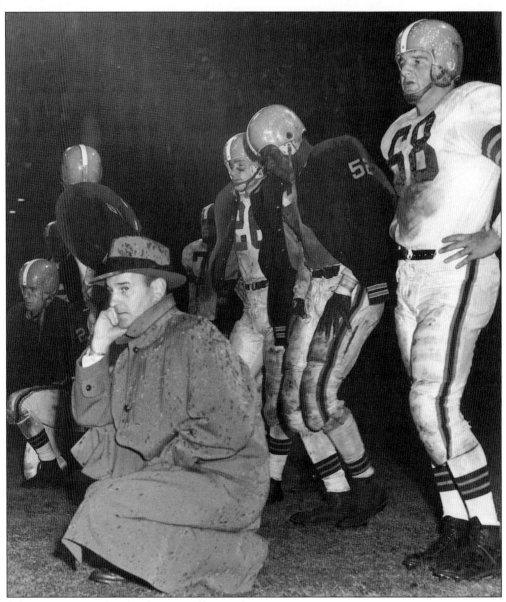

(Photo Courtesy Cleveland Press Collection.)

CLEVELAND BROWNS HISTORY

Frank M. Henkel

ARCADIA

Published by Arcadia Publishing
an imprint of Tempus Publishing Inc.
Charleston SC, Chicago IL, Portsmouth NH, San Francisco CA

Printed in Great Britain

Library of Congress Catalog Card Number: 2005925064

For all general information contact Arcadia Publishing at:
Telephone 843-853-2070
Fax 843-853-0044
E-mail sales@arcadiapublishing.com
For customer service and orders:
Toll-Free 1-888-313-2665

Visit us on the internet at http://www.arcadiapublishing.com

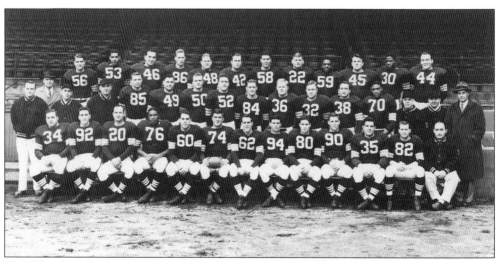

The Cleveland Browns dominated the All America Football Conference from 1946 through 1949, but moved to the NFL amid a flurry of skepticism. They soon put their skeptics to rest, breezing through the regular season and winning the 1950 NFL Championship. (Photo Courtesy Cleveland Press Collection.)

CONTENTS

ACKNOWLEDGMENTS

Writing a book was a childhood dream of mine that I thought would never be realized, much like being a "baseball player." That all changed when Jeff Ruetsche of Arcadia Publishing contacted me in August of 2004 and asked if I'd like to write a book about the Browns. Thanks to Jeff, John Pearson, Roy Taylor (author of *Chicago Bears History*), and everyone at Arcadia, this dream was realized. If only the Indians needed someone to play deep, deep right field!

Truthfully, it takes an army to assemble a book, and I was lucky enough to have one at my disposal for this project. I could take up three pages with nothing more than a list of names, but I'd like to recognize the following individuals who offered up more help than they really had to. I really couldn't have finished this project without the help of my friend and successful author Roger Gordon. His unwavering confidence in me pulled me through, and his teachings of book etiquette took me a long way. Even though he wanted to wait for the final product, he happily read every word I sent to him before hand, and this project would be incomplete without his research.

Of course, it is quite difficult to create an Images of Sports book without the images. The wonderful people at the Cleveland Press Collection, especially Bill Barrow and Bill Becker, were instrumental in the making of this book. They let me set up a mini-office in their library, and gave me good advice while I scanned every photograph I needed to complete this project. Vince Lavalle of Ultimate Photo provided the great cover image of Bernie Kosar, as well as other photos used throughout the book. It's amazing to think that Vince only shot one Browns game in his life, and he ended up with an image that defined the team for a generation of fans. Aaron Josefczyk, another great photographer, snapped the back cover photo of Dwayne Rudd, as well as many of the photographs which appear in Chapter Nine. Finally, Ron Schwane came through at the last second with the great snapshot of new Browns coach Romeo Crennel; Ron is a true professional.

Bob Carroll of the Professional Football Researcher's Association gave me some great tips on research and photo acquisition. John Richards' 1949 game footage was a huge help as well. Other PFRA members who helped through their writings were Stan Grosshandler, Doug Warren, Todd Maher, Bob Gill, Andy Piascik, and "Coach" TJ Troupe. Thanks to all!

I would also like to give a special thanks to my wife, Elizabeth. She read and proof-read every word of this book even though football is one of her least-favorite topics. I'm sure that she knows way more about the team than she ever thought or hoped she would, and I hope she knows that I couldn't have done this or much of anything else without her love and support.

I'd also like to thank the following people: Bryan and Alicia Earls; Colin Clowes; Greg "B50" Earls; Mark "limaguy" Gordon and all of the guys from www.cyberpound.com; Derrek "Fishbone" Fisher; Jeremy Burnham; "Historian"; and the rest of the contributors to my website, www.nflhistory.net.

Finally, to every Browns fan who, like me, longs for the glory of the past, this one's for you.

INTRODUCTION

As time goes by, only the most significant events seem to stick in our minds. Few are those who were alive when Art "Mickey" McBride flew to Chicago in 1945 in order to purchase a pro football team for the city of Cleveland. Fewer still are those who can recall the *Chicago Tribune's* sole headline introducing the All America Football Conference. The rest of us rely on books such as this to tell the stories our memories or age cannot.

Legends Mickey McBride and Paul Brown are always mentioned when discussing the origins of the Browns. They are followed closely by Hall of Fame players like quarterback Otto Graham, kicker Lou Groza, and running back Marion Motley. Others, such as Frank Leahey, however, rarely make the conversation.

Leahey was the head football coach at the University of Notre Dame from 1941 to 1943 before he was called to serve in World War II. As the war drew to a close, the university eagerly anticipated the return of its coach. Art McBride, a Fighting Irish fan, wanted Leahey to coach his club when they began play in 1946. Although McBride was prepared to pay top-dollar for the coach, he was convinced by Notre Dame President John Cavanaugh to withdraw his pursuit, allowing the Irish to keep their popular coach. The Cleveland owner would eventually select Paul Brown to lead his new franchise. The rest is *Cleveland Browns History*.

Cleveland Browns History will bring stories like Leahey's to the forefront. The career of backup quarterback Cliff Lewis, for instance, which started off strong as he led the team to its first two victories, has been reduced to a trivia question over the last half-century. Likewise, Ernie Green was a bruising runner with great hands out of the backfield in the 1960s, but he was an even better blocker and was tasked with blowing holes open for Hall of Fame runners Jimmy Brown and Leroy Kelly. The stories of men like these deserve more than a footnote at the bottom of a page.

Understandably, men like Lewis and Green aren't the face of the Browns. They, like so many before and after them, had the talent and potential to become legends but accepted their roles to pave the way for others. In doing so, they've sacrificed a larger place in Browns history.

The penthouse suite in Cleveland sports lore is rightfully reserved for the Hall of Fame players like Graham, Groza, Brown, and Kelly. Stories of championship seasons, Dawg Pounds, jinxes, infamous drives, and unfortunate fumbles are passed down from one generation of fans to the next and are chronicled in the history books because they are the legends that stir our emotions. Sometimes though, seasons like 1979 are remembered only as a winning percentage, rather than 16 straight weeks of heart-pounding excitement.

This book relives seasons like 1979, which brought the same exhilaration to fans as the title years did, yet failed to provide the satisfaction of a championship trophy. *Cleveland Browns History* chronicles the individuals whose careers are remembered in Canton, Ohio, but also explores the role-players who helped turn those special talents into legends, from the team's subtle 1946 beginning to the fanfare of its 1999 return and beyond.

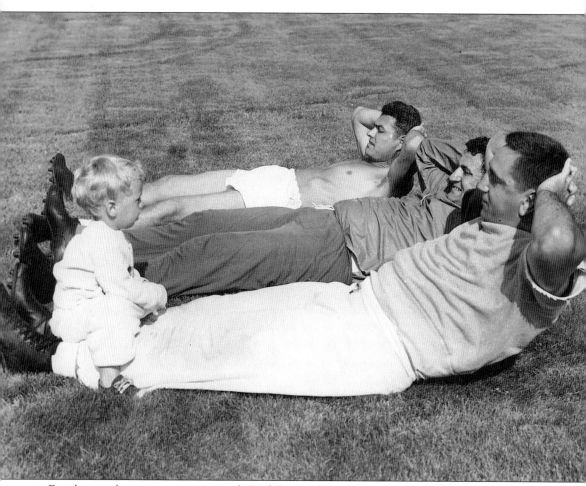

Family was always a top priority with Paul Brown. During training camp, he found hotels for the wives and children of his players and coaching staff. Each week, the players, coaches, and their families would all gather for dinner. Here, seen from top to bottom, Dante Lavelli, Don Colo, and Lou Groza get in shape before training camp in 1955, as Groza's son cheers on his dad. (Courtesy of the Cleveland Press Collection, Fred Bottomer.)

ONE

Creating and Destroying the AFC

1946–1949

Four AAFC Championships

Mickey McBride was already a successful and wealthy executive by his 40th birthday. He was most notable in Cleveland for owning the city's Yellow Cab Company, but he built his fortune in the newspaper business in Chicago and Cleveland, real-estate, and a sports-wire outfit. Mickey was never much of a sports fan and did not follow football until his sons began attending Notre Dame in the early 1940s.

McBride developed such a fondness for the game that he attempted to buy Cleveland's Rams, owned by Daniel F. Reeves, but the Rams were not for sale. When Arch Ward decided to put his plan for a new league called the All-America Football Conference (AAFC) into action, Mickey jumped at the chance to buy a team for Cleveland.

Although McBride welcomed the fan-base competition with the 1945 NFL Champion Rams, that would never happen as Reeves packed up his Rams and moved them to Los Angeles. The 1945 NFL champions became known as the "Scrams" in Cleveland newspapers for years to come. To McBride's benefit, Cleveland's new AAFC team would not have to compete with an established NFL club for its fan base.

Creating a Team, a League, and a Legacy

With the Rams out of the picture, McBride focused on building his team, and his first task was to find a head coach. Since Mickey did not know much about football outside of Notre Dame, he pursued Frank Leahey, the pre-war coach of the Fighting Irish. Leahey and McBride agreed on the terms of the deal, but word got back to the president of the university, Reverend John Cavanaugh. Cavanaugh explained to McBride that the school was looking forward to having its coach back after the war and convinced him to look elsewhere for a coach.

A Cleveland sports reporter suggested Paul E. Brown, a very popular Ohio coach, to McBride. Lieutenant Brown, who was currently coaching at the Great Lakes Naval Training Center in Lake County, Illinois, had led the Ohio State Buckeyes to the college national championship before serving in the Navy. Prior to that, Brown guided the Massillon Tigers, a Canton, Ohio high-school team, to greatness. McBride, who may have decided to contact Brown based on the coach's regional popularity more than his résumé, enlisted Arch Ward to negotiate Brown's contract.

Early in 1945, Brown became Ward's top priority because of the notoriety he would bring to the new league. After meeting with Ward, McBride, and minority owner Dan Sherby, Brown signed a contract to coach in Cleveland. The deal called for an annual salary of $25,000, a five percent stake in the club, and complete control over personnel.

Paul Brown enjoyed so much control of the team that one of the last tasks Mickey McBride oversaw was the contest to name it. McBride initially paid out a $1,000 war bond to the person who submitted "Cleveland Panthers," but soon discovered that the name represented a 1926 NFL team, so a second contest was held. McBride decided to pick the most common entry for the second contest, and that entry was overwhelmingly "Browns" in honor of the team's popular coach. Initially, Brown stated that the team was actually named for Joe Louis, the Brown Bomber. The coach's claimed that "Brown Bombers" was the most common entry, but later recanted, agreeing that the team was named for him.

The end of the war triggered military discharges for many former college football stars, just as Arch Ward anticipated. This enabled AAFC teams to sign many players who would have normally been under contract with the NFL, and helped the new league avoid costly bidding wars for players. One such player was Otto Graham, the first player signed by Paul Brown. Brown remembered the quarterback guiding Northwestern University to two wins against Brown's Ohio State Buckeyes in 1941 and 1943. Graham was serving out his last days at Glenview Naval Air Station, also in Illinois, when Brown first contacted him, and the coach offered a $7,500 contract and a $250-per-month retainer to Graham for the duration of his military service.

Brown acquired most of his players in the same manner. Lou Groza, Lin Houston, and John Yonaker—all of whom played for Brown at Ohio State—received contracts and retainers through the mail as they finished out their service. The same happened for Edgar "Special Delivery" Jones, Lou Saban, Mac Speedie, and others that Brown remembered coaching against at Great Lakes, Ohio State, or Massillon.

Some of Brown's new players did come from the NFL, however. Three former Rams—Tom Colella, Don Greenwood, and Chet Adams—preferred to stay in Cleveland rather than move to Los Angeles. They claimed that their player contracts promised them to *Cleveland*, and since the Rams were no longer in the city, their contracts were no longer valid. A judge sided with the players, and they all signed with the new Browns.

As training camp opened before the 1946 season, the roster was nearly complete. Two late additions had a large impact on the success of the Browns, and an even bigger impact on professional sports for decades to come. Bill Willis was an offensive lineman for Brown at Ohio State, and Marion Motley was a bruising fullback who played against Brown's Massillon teams while attending Canton McKinley High School. Both men were black, and even though there was no rule against black players in football, none played in pro football's post-1932 era. Paul Brown did not see any player as a skin color, though. He was determined to sign the best

football players, regardless of race, and so the Browns became the first integrated team in professional football.

Often Battered, Hardly Beaten

The Browns came from behind in their only pre-season contest of 1946. After falling behind, 13-0, to the Brooklyn Dodgers, Cleveland roared back to win the game, 35-20. The Browns were ready to open their inaugural season against the Miami Seahawks, with one caveat. Otto Graham, who just played in the College All-Star Game, another of Arch Ward's inventions, had not yet grasped Paul Brown's offense, so Cliff Lewis became the first starting quarterback for the new franchise.

Lewis was more than just a backup quarterback. Paul Brown called him one of the three greatest quarterbacks he ever coached, and plainly stated that, "Cliff would easily have been our starting quarterback," if Otto Graham was not on the team. Lewis was so strong and athletic that he was Cleveland's starting safety during his six years with the club.

With two contests to name the team, a popular coach, and many former Ohio high school and college athletes on the team, Mickey McBride had plenty of opportunity to promote the Browns. This promotion paid dividends on opening night as over 60,000 football fans flooded Municipal Stadium for the AAFC's first contest, the largest crowd ever to see a regular season pro game. The NFL Champion Rams did not even draw half of that during any regular-season contest during the previous year and were only able to attract a little more than 32,000 for the championship game.

The fans, and the Seahawks, were treated to a Paul Brown football clinic. Lewis opened the scoring with a 19-yard pass to Mac Speedie just eight plays into the first quarter. Bill Willis wreaked havoc, hardly ever allowing a clean center-to-quarterback exchange all game long. After a Lou Groza field goal made it 10-0, Graham debuted in the second quarter and completed a 39-yard pass to Lavelli for Cleveland's second touchdown. Former Rams back Tom Colella added another touchdown and Groza added another field goal before halftime to essentially seal the victory. Two defensive touchdowns sandwiched another Groza field goal in the fourth quarter to finish the game and the coach's clinic; the Browns won, 44-0.

The Browns proved that their opening-day success was no fluke when they rolled off six consecutive victories after the Miami game. The 4-3 San Francisco 49ers finally handed the 7-0 Browns their first loss when they came into Cleveland and trounced the Browns. The final score of 34-20 was not indicative of how lopsided the game was, because Cleveland scored two touchdowns in the final quarter. That loss was followed by a heart-breaking 17-16 defeat at the hands of the Los Angeles Dons. The Dons, who came into the contest with a 3-3-1 mark, rallied to score 10 points in the final period, including a short field goal in the final minute to seal the victory.

After exacting revenge on the 49ers the following week, the Browns won their final four games by a combined score of 193 to 45. The closest game in that stretch was a 42-17 blowout of the Buffalo Bisons. The last game in the streak was against the same Brooklyn Dodgers that the Browns rallied to beat in the pre-season. The Browns blew the Dodgers away, 66-14, jumping out to a 21-0 lead early in the second quarter and extending that lead to 52-7 in the fourth. The Browns finished the season with an impressive 12-2 record and played the New York Yankees for the first AAFC title.

The Yankees, who were owned by Dan Topping of the baseball Yankees, were designed for success. Their roster contained stars such as Orban "Spec" Sanders, Buddy Young, and Arnie Weinmeister, among others. Ray Flaherty, the team's coach, previously guided the NFL's Redskins to championships in 1937 and 1942. In addition, they were named for pro baseball's most dominant team.

A rivalry developed between the two clubs and their fans. Flaherty fueled the fire when, in a heated moment, he commented that the Browns were "a team from Podunk with a high school coach." Although Brown never gave credence to the remark, it was good fodder for

11

newspaper reporters and excellent bulletin board material for the locker room. Entering their first match up, both teams sported 3-0 records, but Cleveland bested New York, 27-7. The rematch two weeks later also went in Cleveland's favor, this time by a score of 7-0. Key Yankee turnovers decided both games, even though the teams were evenly matched.

The championship game brought more of the same thrills and fiery play as the first two contests. After New York's Harvey Johnson scored on a first quarter field goal, Otto Graham orchestrated a drive Marion Motley capped with a two-yard touchdown run to put the Browns on top, 7-3. The lead lasted into the third quarter until Spec Sanders matched Motley's two-yard score with one of his own. As time waned in the fourth quarter, Graham connected with Dante Lavelli on a 16-yard touchdown pass that gave the lead back to the Browns, 14-9. As in the first two contests between the clubs, a Yankee turnover decided this game when Graham, who played defensive back as well as quarterback, picked off a pass in the final minutes to preserve the 14-9 lead and seal the championship for Cleveland.

The Browns ended the 1946 season riding a six-game winning streak with their explosive offense and suffocating defense. On offense, Lou Groza led the league in scoring, Graham led in passing, and Lavelli led in receptions and yards per catch. Marion Motley set a professional record with 8.2 yards per rush. Meanwhile, Bill Willis emerged as the most dominating defensive player in the league, and the defensive unit gave up fewer than 10 points per game.

Nevertheless, Paul Brown continued to add to his already impressive talent pool in 1947. Horace Gillom, an excellent punter, could also have started at offensive end (the modern-day wide receiver) for any other team in pro football. Weldon Humble, the standout guard from Texas, was acquired in a five player trade with Baltimore and solidified the already stout Browns offensive line. Finally, Tony Adamle, a devastating linebacker, played for Brown at Ohio State. He, unlike Groza and Lavelli, returned to the university following his war stint. He was later drafted by the Bears of the NFL, but opted to sign with Brown instead.

Cleveland continued its success both on the field and at the gate in 1947. The Browns again drew more than 60,000 for their home opener against Buffalo, renamed the Bills, and easily won 30-14. Four more wins, including one against the Yankees in front of a record-breaking crowd of over 80,000 at Municipal Stadium, followed before the Los Angeles Dons came to town and upset the Browns, 13-10. The Browns held a 10-0 lead before fumbling the game away to the Dons. Cleveland would not lose again for almost two years.

After ripping off another five-game winning streak, the Browns traveled to New York to face their archrivals, the Yankees. More than 70,000 fans packed Yankee Stadium to see if the home club could finally break through against the Browns. Those fans were treated to two consecutive Spec Sanders touchdown runs in the first quarter, followed by another in the second. Fullback Buddy Young pounded a five-yard run in before the half to improve the score to 28-0. Cleveland came out firing on all cylinders in the third, though. First, Otto Graham hit Bill Boedeker out of the backfield for a 34-yard touchdown, and then he connected with Motley for a 12-yard score. In the fourth quarter, Motley reached the end zone again on a 10-yard romp. With time running out at the end of the game, the Browns found themselves with the ball 90 yards away from a tie. Graham orchestrated a magnificent drive, culminating in a Jim Dewar touchdown run with four seconds left. Lou Saban, filling in for the injured Lou Groza, barely kicked the extra point through the uprights, and Cleveland escaped with a 28-28 tie.

The Browns rounded out the season with a 27-17 win over the Dons and a 42-0 pounding of the Colts, who were the regrouped Miami Seahawks of 1946. Cleveland finished the year with an impressive 12-1-1 record in the AAFC Western Division. Despite New York's trouble against the Browns, they won the Eastern Division title for the second year in a row with an 11-2-1 mark. The teams met again in New York to decide the league's championship. The Browns took home the title, this time in a 14-3 defensive battle, and they proved their dominance over the Yankees and the entire league. Lavelli, Speedie, Rymkus, Willis, Motley, and Graham won all-league honors, while Graham also picked up the league's MVP award.

As the Browns continued to prosper, other AAFC teams began to falter. Some, such as the

Seahawks of 1946, had already folded. Others, like their reformed team, the Colts, were on the verge of going under. A number of other teams, such as the Dodgers, changed owners and were losing money quickly. The disparity between good and bad teams was so great that the league mandated Cleveland and the other good teams to give players to the lesser teams, and the Browns gave up future Hall of Fame quarterback Y.A. Tittle to the Colts.

Despite the loss of Tittle, the Browns continued to be the class of the AAFC. After a close 19-14 victory against the Dons in the 1948 home opener, Cleveland won eight in a row by an average of 18 points. The Browns were so good, in fact, that attendance began to suffer, at home *and* on the road. Cleveland, who drew under 40,000 in only three of 16 previous home games, saw a crowd larger than that just once during the stretch, when 46,912 saw the Browns trounce the Yankees, 35-7.

In week 10, the 9-0 Browns took on the 9-0 49ers at Cleveland Municipal Stadium. Over 82,000 fans came to see the battle of the unbeaten, and were treated to one of the only competitive games of the season. First quarter touchdowns were traded between Graham and 49ers fullback Joe Perry. A third quarter touchdown by Special Delivery Jones capped the scoring as the Browns remained unbeaten. Just as quickly as the Yankees rivalry died, a new one with San Francisco was born.

The only thing that stood between the Browns and an undefeated season was their schedule. Cleveland had a grueling stretch of three games ahead of them over the next eight days, traveling to New York, Los Angeles, and San Francisco to play a Sunday-Thursday-Sunday slate. On November 21, they handled the Yankees easily, winning 34-21. On Thanksgiving Day, four days later, Otto Graham threw two touchdowns and ran for another in a 31-14 win over the Dons, but suffered a knee injury that forced him out of the game.

Cleveland then traveled north to face the 11-1 49ers in one of the greatest AAFC contests ever. The deck was stacked against the Browns, though when they arrived at Kezar Stadium on just two days of rest. They needed to win on the road against the best team in the league—next to the Browns—and Brown planned to sit Graham because his knee was still sore.

The game got off to a good start for the Browns as the 49ers fumbled the opening kickoff. To the surprise of everyone in the stadium, Otto Graham trotted out with the offensive unit for Cleveland's first series, and on the first play, threw a 28-yard strike to Dante Lavelli for a touchdown. Cleveland opened up a 10-0 lead in the first period before giving up two touchdowns in the second, and trailed 14-10 at the half. San Francisco opened the scoring in the third quarter on Alyn Beals' touchdown catch, his second of the game. The Browns, down by 11, drove the ensuing kickoff down the field and scored to cut the deficit to four. After the Browns held the 49ers, Graham tossed a 20-yard score to Dub Jones that put the Browns on top, 24-21. A third consecutive touchdown by the Browns gave the team a 10-point lead, and the defense held off a 49ers comeback attempt to win, 31-28.

Destroying a League

The win against San Francisco pushed Cleveland's unbeaten streak to 21 games, and capped the first ever stretch of three wins in eight days. The Browns proved to experts everywhere that it would be tough to beat them in the future. Unfortunately for the AAFC, this became quite evident to fans as well.

After a well-deserved six-day break, the Browns traveled to Brooklyn and beat the Dodgers, 31-21, in the season finale to cap the first perfect regular season since the 1942 Chicago Bears of the NFL. Less than 10,000 fans showed up to the game though, the lowest total for a Browns game since 1946 when the team traveled to Miami to face the bankrupt Seahawks. The Browns returned home two weeks later for their third consecutive AAFC championship game against the Bills. Although they easily handled the Bills, 49-7, less than 23,000 fans turned out to witness the first team to run the table *and* win its league championship.

The amazing streak stood at 23 games with no end in sight. Competition with the NFL for

players escalated salaries to never before seen territory, while dwindling attendance riddled just about every AAFC team, even the mighty Browns. The league's financial and competitive problems, which really started before the 1948 season but were compounded during it, drove many of the league's millionaire owners either out of the football business or to the edge of a bailout. The 1949 version of the AAFC only included seven teams: Baltimore, Buffalo, Chicago, Cleveland, Los Angeles, New York (who absorbed Brooklyn), and San Francisco.

Things quickly worsened for the once-promising league when the Browns started out the season 4-0-1. The one blemish on their record in 1949 was a 28-28 tie with the Bills on opening night in Buffalo. Although the Browns jumped out to a 7-0 lead early in the first half, Buffalo tied the game by halftime and scored three more times in the third, thanks to key Cleveland turnovers. Even when down 28-7 in the fourth quarter, the Browns could not seem to lose. Otto Graham hit 14 of 16 passes in the final stanza, three for touchdowns. That final touchdown, an unbelievable catch by Mac Speedie, allowed the Browns to escape Buffalo with a 28-28 tie.

The amazing unbeaten streak finally came to an abrupt end in San Francisco when the 49ers thumped the Browns to the tune of 56-28 in week six. The crowd of 59,770 was the largest to see the Browns in 1949. Paul Brown, always the perfectionist, threatened everyone's job on the plane ride back from San Francisco, and the team responded with a 61-14 win over the Dons one week later.

Under the media's radar, the league began merger talks with the NFL. Arch Ward's plan to replace the NFL champions in the College All-Star game failed, as did his plan to play a combined championship game with the established circuit. Even though the Browns attained national prominence, most NFL experts still thought of the AAFC as a minor league.

Meanwhile, the Browns continued to win. After exacting revenge on the 49ers, 30-28, in Cleveland, they beat the Rockets by 33, tied the Bills, 7-7, shut out the Yankees, 31-0, and finished out the season with a 14-6 victory in a virtually empty Soldier Field in Chicago. The Browns beat the Bills in a playoff game by 10 in front of less than 18,000 fans to earn a trip to their fourth consecutive AAFC title game.

Two days before the game, the NFL and AAFC finished their talks on the merger of the rival circuits and announced the results to the press. The Browns, Colts, and 49ers gained entry to the new combined National American Football League, while the clubs of the new league would split up players from the remaining teams. That final title game became a side-note to the merger announcement as the Browns downed the 49ers, 21-7.

The so-called merger became more of a consumption of the AAFC by the NFL. Less than three months after the merger, the NAFL, or NAL, renamed itself the NFL once again and only the three teams of the NFL's choosing were admitted into the league. AAFC statistics, standings, and championships were not deemed official in the new league.

In truth, the war of the leagues was much closer than the final score indicated. The fatal blow to the AAFC owners was their combined success in other business ventures. All were millionaires, but when things became tight, they blinked first. The NFL owners, on the other hand, were mostly football men, gamblers, and heirs to teams, and had grown accustomed to losing money throughout their ownership. Even though the AAFC sold an average of 10,000 more tickets per game, the NFL's negotiators were shrewder and its owners more composed, determining the outcome.

For the Browns, the merger meant finally getting to prove to the world what they believed all along—that they were the best team in pro football. 1950 would not only determine Cleveland's place in history, but would serve to silence the critics who said that the AAFC was the equivalent of minor league baseball.

Mickey McBride (left) bought the rights to Cleveland's entry into the new All America Football Conference in 1945 after a failed attempt to buy the Cleveland Rams. McBride's first hire was legendary Ohio coach Paul Brown (right). McBride handed total control of the team over to Brown, who was free to make decisions about personnel and finances. Brown also owned five percent of the team, which he eventually parlayed into his own franchise, the Cincinnati Bengals, after Art Modell fired him in 1962. (Courtesy of the Cleveland Press Collection.)

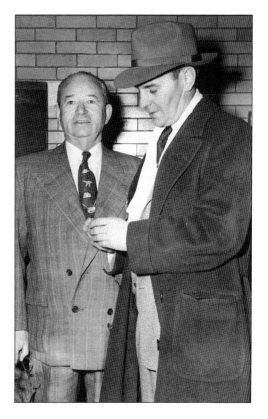

Below, Brown celebrates his second AAFC championship with Otto Graham and Mac Speedie. Though Brown accepted McBride's offer, his true post-war wish was to return to the Ohio State Buckeyes. He enjoyed a great deal of success at Ohio State and loved teaching the young men on the team about both football and life. Carroll Widdoes guided the team to an undefeated season in Brown's absence, earning the job for himself. The university said that it would take Brown back, but he decided that moving on would be the best solution. (Courtesy of the Cleveland Press Collection.)

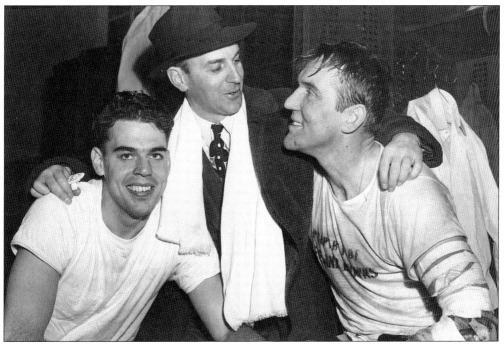

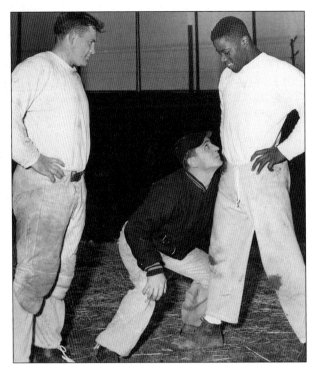

The Cleveland Browns were the first professional football team to integrate when Paul Brown signed Bill Willis (right) and Marion Motley. These two men became vital parts of the team and family members to the organization, although road travel was often perilous. The two stars did not fly with the team to Miami for a game in 1946 because local Miami law prohibited black athletes from competing with whites. The law did not help the Seahawks though, as the Browns pounded the home team, 34-0. (Courtesy of the Cleveland Press Collection.)

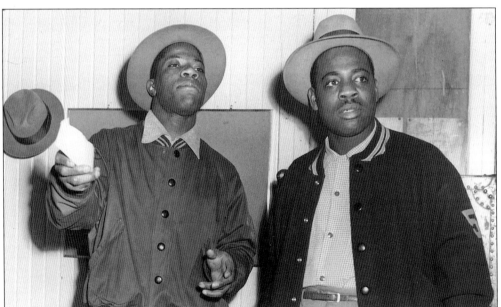

After watching the success of Motley and Willis, and Jackie Robinson in baseball, the floodgates opened for black players in both the AAFC and the NFL. Horace Gillom (right), pictured with Bill Willis, became the greatest punter of his time upon joining Cleveland in 1947. Gillom was also a capable end, often replacing Browns' starters Speedie and Lavelli when they were injured. Certain cities, such as Los Angeles, were still not friendly to blacks, and the Browns would often book hotel reservations outside of those cities so the entire team could stay together. (Courtesy of the Cleveland Press Collection.)

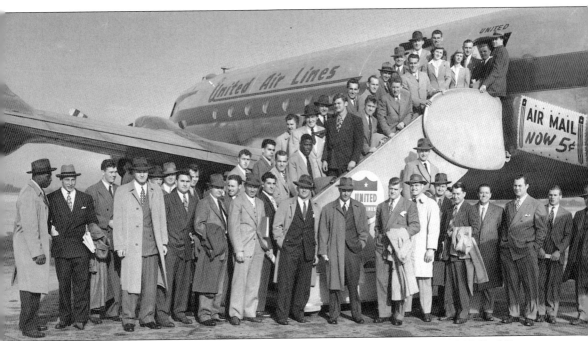

The Cleveland Browns prepare for their first-ever team flight on October 11, 1946. Paul Brown innovated travel in professional sports as the Browns became the first pro team that flew to all road games. On this day, the Browns are heading to New York for a Saturday night contest against the Yankees. The Browns won an ugly 7-0 game on the strength of a late New York turnover. (Courtesy of the Cleveland Press Collection, John Nash.)

Dante "Gluefingers" Lavelli rakes in a deep pass from Otto Graham near the sidelines. Lavelli earned his nickname by catching everything thrown his way. In 1946, Graham threw the ball to him 40 times, and Lavelli made all 40 receptions. Many thought that Lavelli had the best hands in the history of the game, and Graham agreed: "If I had to throw the ball to one person and he had to get a first down, it would be Lavelli, because of his hands." (Courtesy of the Cleveland Press Collection.)

The Browns capped their first AAFC season in 1946 by beating the New York Yankees, 14-9. After the game, seen here from left to right, Otto Graham, Dante Lavelli, Paul Brown, and Mac Speedie celebrate the hard-earned win. In the game, Lavelli scored the go-ahead touchdown in the fourth quarter, and Graham preserved the win with an interception late in the game. (Courtesy of the Cleveland Press Collection.)

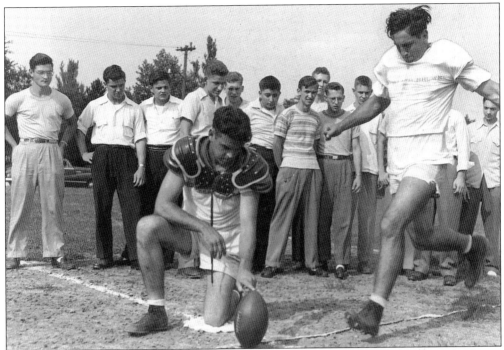

Lou "The Toe" Groza teaches the proper kicking technique to a group of Cleveland area youngsters, while Otto Graham holds the ball. Although most noted for his kicking exploits, Groza was also a very capable offensive tackle until 1960, when back injuries forced him off the line. Groza earned All Pro honors as a lineman seven times in his career. (Courtesy of the Cleveland Press Collection.)

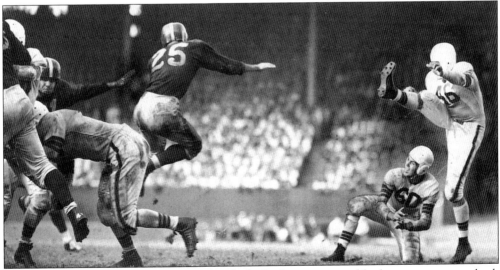

Otto Graham looks up at a Lou Groza placekick. Graham was arguably the greatest quarterback in pro football history, but like Groza, he was also multi-talented. Aside from throwing and holding, Graham was an excellent runner, defender, and return man. Graham scored 44 rushing touchdowns in his career, intercepted seven passes, and was the Browns' dedicated punt returner during his first three seasons. (Cleveland Press Collection, John Nash)

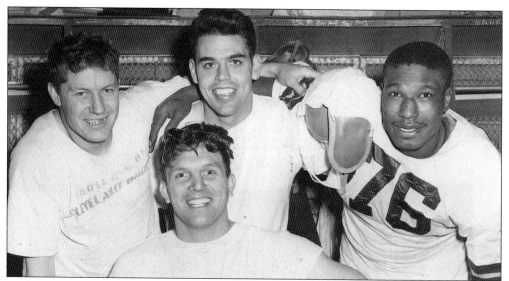

Edgar "Special Delivery" Jones, Lou Saban, Otto Graham, and Marion Motley celebrate the Browns' 49-7 pounding of the Buffalo Bills in the 1948 AAFC Championship Game. With the win, Cleveland completed the first perfect season in football history; only the 1972 Miami Dolphins have matched the feat. Two years later when the AAFC merged with the NFL, the Browns absorbed the Buffalo franchise after the Bills failed to gain entry into the league for the 1950 season. (Courtesy of the Cleveland Press Collection.)

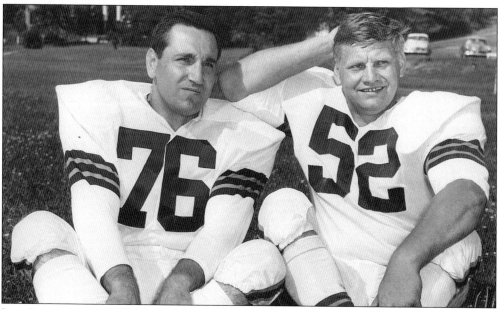

Lou Groza poses with Frank "Gunner" Gatski during training camp. Gatski was the Browns' center for 10 seasons, and never missed a practice, much less a game, in his entire career. The Browns were so confident in Gunner's durability that they did not even carry a backup center on the team for most of his career. Gatski replaced previous center Jim Daniell on the line in 1946 after Paul Brown cut Daniell from the team for brawling and getting arrested. (Courtesy of the Cleveland Press Collection, Fred Bottomer.)

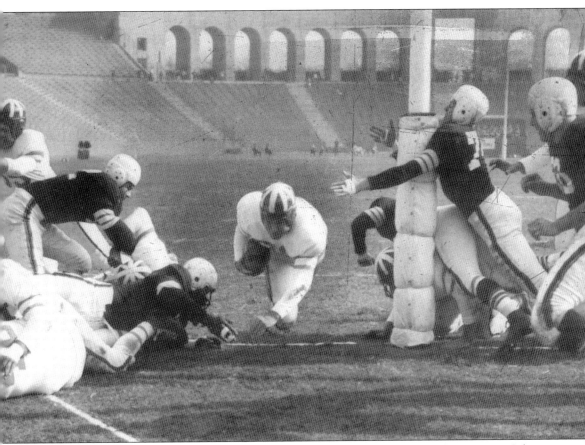

LA Dons fullback Walt Clay hurdles over the goal line in a 31-14 loss against the Browns as John Yonaker runs into the goal post attempting to make the tackle. The game was played on Thanksgiving Day 1948, in a week that saw the Browns play three road games in eight days. The Browns won the first game in New York against the Yankees, beat the Dons in the second, and nipped the 49ers in the third game on just two days of rest. The Browns became the only team in history to win three games in eight days. Dante Lavelli still refers to the accomplishment as the team's greatest achievement. (Courtesy of the Cleveland Press Collection.)

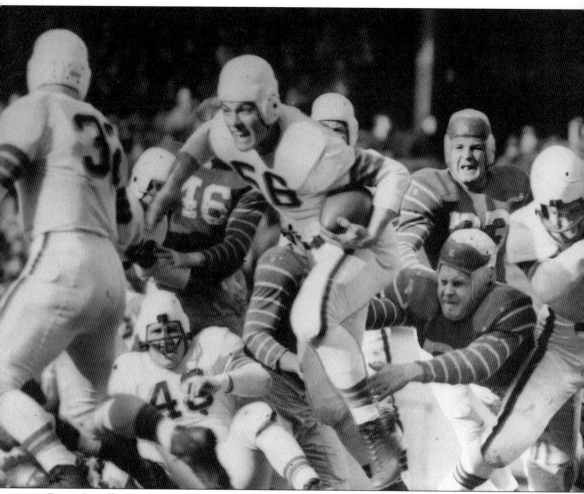

Dante Lavelli runs for 14 yards against the Buffalo Bisons. Lavelli had 143 catches, 2,580 yards, and 29 touchdowns while the Browns dominated the AAFC, but the NFL refused to accept those statistics because the two leagues never played against each other and the AAFC never provided play-by-play accounts of their games. This bothered Paul Brown: "The play-by-play sheets of the NFL were no better than those kept by the AA[F]C . . . and their accuracy has never been challenged." Brown contended that was "unfair because the statistics compiled by Lou Groza, Dub Jones, Dante Lavelli, Marion Motley, and Otto Graham, among others . . . would give deserved added luster to their careers." Later, the Pro Football Hall of Fame in Canton, Ohio, decided to recognize the accomplishments of players, coaches, and teams who participated in the AAFC. (Courtesy of the Cleveland Press Collection, John Nash.)

Two
New League, Old Result
1950–1955

Three NFL Championships

For four years, Paul Brown and his team dominated the All America Conference, losing just four times in that span while claiming the league's championship each season. Yet, the media in NFL markets largely dismissed the accomplishments of the Browns, comparing them to a very good minor league baseball team. This did not sit well with Brown and his team. Every member of the Browns wanted to compete with the NFL's elite, especially Otto Graham. In fact, Graham later recounted that, "We would have gone in and played the [NFL champion Philadelphia Eagles] for anything, just to prove we were as good as they were." Money was not the motivator, according to Graham; he would have played them "for a chocolate milkshake." When the chance to play in the NFL arrived, it was of no surprise to anyone in the Browns organization, especially Coach Brown. He, like many others, knew that a combined league was inevitable, and he started scouting the Eagles a good year before the merger, by studying film and developing a game plan for Philadelphia.

The Browns opened 1950 with some tune-up games during the pre season. In the first game against the Packers, Green Bay drove the ball right down the field and scored a touchdown to open that game. For a moment, Brown doubted whether the Browns belonged in the NFL. That doubt was erased quickly, though, when Cleveland put up 38 points in a row to easily win the contest. The Browns finished the pre season with wins against the Chicago Bears and the Detroit Lions as they anxiously awaited their first NFL challenge: The Philadelphia Eagles.

Brown's Town: Paul Brown Silences the Critics

Arch Ward's dream of an AAFC/NFL championship game somewhat came to fruition on September 16, 1950, as NFL schedule makers, along with Commissioner Bert Bell and Paul Brown, decided that there was no better way to start the season than to pit the two champs against each other in a Saturday night match up. Although Eagles All Pro halfback Steve Van Buren would not play due to injury, the Browns entered the contest as huge underdogs, which gave Cleveland additional, but unneeded, motivation.

Over 71,000 fans packed into Philadelphia Municipal Stadium to see one of the most anticipated pro football games of all time. After stopping the Eagles on their first possession, Don Phelps returned a punt for a touchdown. Game officials flagged Len Ford for clipping on the play, though, so the ball was punted again. This time, it landed out of bounds at the Cleveland 41-yard line. After reviewing the game film later in the week, Paul Brown claimed that Ford's block was legal, and the big defender had actually blocked three tacklers at once on the play. Despite the penalty, Cleveland took over on their own 41-yard line. After the offense's first play of the game, Dub Jones, the speedy halfback who was playing offensive end in the contest, told Graham in the huddle that he would be open deep on the next play. Sure enough, Jones faked to the outside and broke up the field, causing his defender to cross his legs. Graham hit Jones in stride for an easy 59-yard touchdown pass.

The Eagles twice drove inside Cleveland's 10-yard line after that due in part to Cleveland's defense, which played with more raw emotion than deadly precision. Both drives stalled, and the Eagles netted just three total points; the Browns led the mighty Eagles after one quarter, 7–3.

The 7-3 lead would be Cleveland's smallest of the night. The defense settled down while the offense found a rhythm. Graham tossed a touchdown each to Dante Lavelli and Mac Speedie in the second and third quarters, respectively. In the final period, Graham ran it in himself from a yard out, giving the Browns a commanding 28-3 lead. Even though Pete Pihos caught a 17-yard touchdown for Philadelphia, the game had already been decided. Rex Bumgardner rounded out the scoring for Cleveland with a two-yard plunge as the Browns won the battle of champions, 35-10.

The Browns thoroughly embarrassed the Eagles, the rest of the league, and most of the national media by destroying the defending NFL champions. Not only did Cleveland win by 25 points on the road, they also had two touchdowns called back because of phantom penalties and sat on the ball for much of the fourth quarter. Greasy Neale, coach of the Eagles, showed his frustration with the loss with his comments to the press afterwards: "Why all they do is pass and trap, and they're like a basketball team the way they throw the ball around!"

The rest of the 1950 season followed the pattern of that first game. The Browns dominated most of their competition, and finished with a 10-2 record, tied for the best in the American Conference. The New York Giants, the other 10-2 team in the conference, handed the Browns their only two losses of the season. League rules stated that the conference winner would be determined by a one game playoff, the winner of which would go to the NFL title game.

New York's defense proved to be the toughest in the league for the Browns. The Giants' secondary was superb, headlined by Pro Bowler Emlen Tunnell and AAFC holdover Tom Landry. New York's defensive philosophy, known as the umbrella defense, was equally as intimidating. The Giants coaching staff designed the scheme to slow down Cleveland's fast group of ends, and it worked. During the regular season, the Giants shut out the Browns, 6-0, in week three, and then beat them again, 17-13, in week six. The 33,054 fans who braved the 10 degree weather would be treated to another great defensive battle.

Cleveland started the scoring early, driving 64 yards down to the New York four-yard line. The drive stalled, though, and Lou Groza booted a field goal to give the Browns an early 3-0 advantage. The teams battled through the middle quarters to a scoreless draw. In the fourth,

Gene Roberts of the Giants took an end-around run down the sidelines for what looked to be a go-ahead touchdown, but Bill Willis made an outstanding tackle at the Browns' four-yard line. After two Eddie Price runs that netted one total yard, New York scored an apparent touchdown, which was called back for an offsides penalty. The Browns then intercepted the ball, but were also called for a penalty, defensive holding, giving the Giants another first-and-goal from the four-yard line. The drive eventually stalled on the 13-yard line after a New York penalty and a four-yard loss. The Giants, having had seven shots at the end zone, had to settle for a field goal and a 3-3 tie. Otto Graham drove the Browns for the winning score, which ended with Lou Groza's 29-yard boot and a 6-3 lead. New York's final push never got started as they were tackled in the end zone for a safety with eight seconds left.

The 8-3 win pushed the Browns into the NFL title game against the team that left Cleveland five years earlier, the Rams. Bob Waterfield's 82-yard scoring pass to Glenn Davis on the first play of the game set the tone, but Graham answered with a TD pass of his own. The team traded touchdowns again before the half, although Groza missed an extra point. More of the same followed in the second half when Cleveland scored in the third and Los Angeles answered in the fourth. The Rams scored on the next play, recovering a fumbled kickoff for another touchdown and a 28-20 lead.

The most important moment of the game came later in the final period. Graham, with his team down 28-27 late but driving for the winning score, took off with the ball and fumbled on the play. As he dolefully walked back to the sideline, he anticipated a tongue-lashing from Paul Brown. The coach, known for looks and words that could cut a man's soul, instead patted the quarterback on the back and said, "Don't worry Otts; we're still going to get 'em."

The defense ended up holding the Rams, and after a punt, Graham and the offense drove down for the winning score, a 16-yard field goal with seconds left. Graham credits Brown and his pep talk with the win. "There's no doubt in my mind that Paul Brown patting me on the back had more to do with us winning that ball game than me throwing the ball or someone catching the ball," remembered Graham.

Paul Brown confessed that he saw the dejection in his quarterback and figured that Graham did not need a lecture at that point: "It hurt me to see this great player standing there so heartbroken." Brown knew that his quarterback would still need to lead a comeback drive, and Graham's confidence needed to be lifted before he got that chance.

The next three years wouldn't go as smoothly for Cleveland. The Browns lost to the 49ers to open the 1951 season. Cleveland swept the rest of the regular season, but the Rams avenged their 1950 title game loss to the Browns by beating them, 24-17. In 1952, the Browns stumbled to an 8-4 record before succumbing to the Lions in the championship game, 17-7. The Browns started the 1953 season 11-0, but a week 12 thrashing by the Eagles ended the perfect season, and Detroit sent the Browns sprawling, 17-16, in the championship game. Although the Browns reached the title game in all three years, they lost each time.

Graham called the 1953 championship game the worst game he ever played, even though his throwing hand was injured. Graham considered retiring after that game, but Otto was a fierce competitor, and he knew that he could never leave on that type of performance, so he would return for the 1954 campaign.

The season started out poorly for the Browns as they were blown out by the Eagles and the Pittsburgh Steelers on their way to a 1-2 record. Graham and his team eventually found their rhythm and peeled off eight straight wins, including a 42-7 payback to the Steelers. The Browns faced the Lions on the last day of the season with hopes of returning to the title game for the fifth straight year.

Detroit was the team that gave the Browns the most trouble. A side effect of having the talent that the Browns did was that they could not keep many good players. In 1950, the Browns had the chance to draft Doak Walker, the great halfback and kicker from Southern Methodist, but since Brown had Motley, Dub Jones, and others, he traded Walker's rights to Detroit for tackle John Sandusky. Since then, Walker haunted the Browns, scoring touchdowns

in each championship game against Cleveland.

The Lions beat the Browns on that last day of the season once again, which marked the fourth victory in a row for Detroit over Cleveland. Brown was more concerned with keeping his championship game plan secret than he was with the outcome of this meaningless contest, but losing to Detroit did not sit well with the players. Before the game, Graham announced that it would be his last. Cleveland's offensive players, led by Dante Lavelli, wanted to ensure that he left as a winner, so they devised their own game plan in the event that the coaching staff's play calling proved to be unproductive.

Lavelli and the offense never got the chance to use their plays. After Doak Walker connected on a 36-yard field goal early on, Paul Brown's game plan was put into action, and it worked perfectly. "Otto-matic" Otto threw for two scores in the first quarter then ran for two in the second before adding a third TD pass late in the first half. He then ran it in one more time in the third quarter as the Browns pounded the Lions, 56-10.

Otto Graham, who had his worst day as a pro in the 1953 title game, had his best one in the 1954 rematch, throwing three scores and running for three more. After conquering the AAFC, making believers of the NFL, beating the Rams who abandoned Cleveland, and exorcising the demons in Detroit, there was nothing else to accomplish for the quarterback who went to the championship game in all nine years that he played, winning six of them. He officially retired after the 1954 season as the greatest quarterback in football history.

Otto's Last Dance: the 1955 Season

Paul Brown never found Graham's replacement, though he had been trying since the early 1950s. Good prospects failed; trades didn't pan out. Going into the 1955 season, Brown's starter was to be George Ratterman, an accurate but immobile passer who achieved modest success in the AAFC. Ratterman's lack of athleticism hurt Cleveland's offense, and even though he had good accuracy with his passes, he couldn't throw the long ball like Graham. The Browns also had Johnny Borton, a 13th round draft choice from Ohio State. Borton wasn't ready to play in the NFL, though. Cleveland also signed Bobby Franklin out of Auburn, but he bolted for the Canadian Football League.

After the Browns lost the College All-Star Game, Brown had dinner with Graham and his wife. There he asked Graham to return for one more season to help the Browns transition to a new quarterback. Graham thought about the coach's proposal and agreed to play one more season, his tenth under the great coach.

Things got off to a shaky start for the Browns. Cleveland lost to a Washington Redskins team that finished 3-9 the year before. Graham called his performance the worst day of his career. He completed just 3 of 9 passes and threw two interceptions before Ratterman relieved him. While the press made excuses for him just returning and not being in shape, Graham knew the truth: "My attitude was all wrong." Otto changed his routine before that game, refusing to be nervous beforehand and eating an unsuitable pre-game meal. He figured that he was doing the team a favor and did not take the game seriously. He never made that mistake again.

Cleveland's next contest was against the 49ers. By this time, San Francisco was no longer a front-running, talented team that gave the Browns fits. Frankie Albert retired, and their great defense of the 1940s was old and ineffective. Since joining the NFL, the 49ers had put a string of winning seasons together, but never even sniffed a title game. San Francisco entered the game 0-1 after losing to the Rams the week before.

Graham, the longtime nemesis of the 49ers, made his final trip to Kezar Stadium. Many great battles between the two teams had taken place on this field, but this wouldn't be one of them. Graham ran in a touchdown in the first quarter. In the second, a 49er drive was halted inside the 15-yard line and they had to settle for a field goal. Cleveland finished the scoring in the first half with running touchdowns by Ed Modzelewski and Fred Morrison that sandwiched a Lou Groza field goal. Cleveland continued to pour it on in the third and fourth quarters with additional touchdown runs as the Browns won, 38-3.

The Browns used a group of runners in the first two games of the season as they tried to find Marion Motley's replacement. Motley missed the entire 1954 season with a knee injury, and was no longer a viable option in the backfield. Although he attempted to return in 1955, numerous injuries throughout his career limited his effectiveness. The Browns tried to use him as a linebacker in preseason, but he had no chance to make the team, so Brown traded him to Pittsburgh for Ed "Big Mo" Modzelewski, another fullback. Big Mo shared time with Maurice Bassett in the backfield, while the Browns also split time at halfback between Fred Morrison, Preston Carpenter, and Bob Smith.

Over the next five games, the rotating running backs paid big dividends. The Browns gained almost 800 yards on the ground in that span while rushing for seven touchdowns. Modzelewski was the only back to top 100 yards in a game, gaining 121 yards in a 26-20 win over the Chicago Cardinals. Cleveland won all five games in that stretch, and went to Philadelphia to face the Eagles with a 6-1 record.

The Eagles, who lost to the Browns in week two, were not able to stop the rushing attack either, which gained 141 yards and scored two touchdowns. They were, though, able to put the clamps on Cleveland's passing attack, holding Graham to 150 yards passing and forcing three interceptions. Graham, who had only thrown two interceptions since the week one loss to Washington, threw two more in this game as the Browns lost, 33-17. It was the final loss of Graham's career.

The Browns easily handled the Steelers, 41-14, at home, and then flew to New York to face the Giants. The Browns and Giants had many great defensive battles since Cleveland's 1950 NFL debut. The teams treated fans to such a great offensive game that some accused the two defenses of taking the day off. New York got off to an early lead, scoring a rushing touchdown in each of the first two quarters. Later in the second, Graham connected with Darrell Brewster for a score to cut the lead in half. Graham threw two long touchdowns in the third quarter, first connecting with Ray Renfro for 42 yards and then with Brewster for 41. Cleveland looked to take command of the game when they got the ball back late in the period, but Bob Schnelker recovered a Browns fumble and returned it for a touchdown to tie the game at 21.

The final quarter of the game was a wild one. New York took the lead with a touchdown pass from Charley Conerly to Kyle Rote, and then the Browns tied it up with a Modzelewski run. Browns linebacker Chuck Noll intercepted Conerly and returned it 14 yards for a score to give Cleveland a 35-28 lead, but New York came back again and tied it on a Frank Gifford touchdown catch. The Browns had one last chance to win the game, and Graham drove the offense down the field to set up a last-second field goal try by Groza. The kick was blocked and the game ended in a 35-35 tie.

The Browns polished off the season by beating the Cardinals by 11, and then headed to their 10th consecutive championship game. This match-up, like Graham's first NFL title game, would pit Cleveland's current team, the Browns, with its former team, the Rams. Although the Browns beat Los Angeles in a close contest for the 1950 crown, they lost to the Rams the following year by a touchdown.

An NFL Championship record 87,695 fans packed into Los Angeles Memorial Coliseum to see the rubber match between the two squads. It was hardly a match at all, though, as Graham picked apart the Rams' zone defense and won the game, 38-14. Otto's last pass was a 35-yard touchdown to Ray Renfro that sealed the game. After the play, Paul Brown took him out of the game, and Rams fans paid tribute to the veteran quarterback, giving him a standing ovation.

When Graham made it to the sideline, he simply said, "Thanks" to his coach. Brown returned the one-word gesture to his All Pro quarterback, and just like that, a prosperous era for Cleveland *and* professional football ended. The quarterback thought of retirement after a tough loss in 1953, then carried out a retirement after his redemption in 1954. He finally followed through after winning it all in 1955. In a game where greatness is determined by winning, Graham led the Browns to ten championship games in ten years, winning seven of them. Others had more touchdowns and yards, but none of them ever won like Otto Graham.

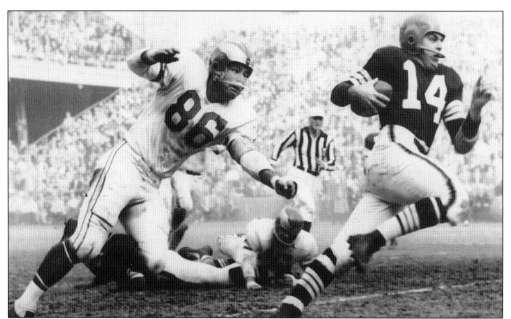

In their first NFL game, the Cleveland Browns destroyed the Philadelphia Eagles, 35-10, on the strength of Otto Graham and the passing game. Afterwards, Eagles' coach Greasy Neale was so incensed that he compared Cleveland's offense to a basketball team. When the teams battled later that season, Paul Brown did not call one passing play, and beat the Eagles, 13-7, on the strength of 41 rushes. The Browns remain the last team in NFL history to rush on every play for an entire game. (Courtesy of the Cleveland Press Collection.)

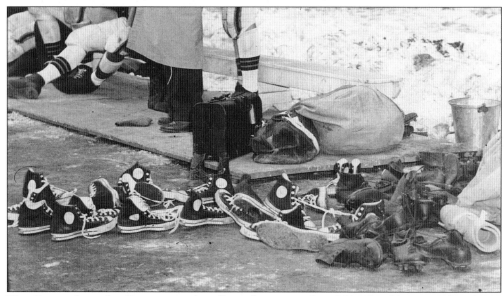

The Browns beat the Giants in a playoff to advance to the 1950 NFL Championship Game against the Los Angeles Rams at Cleveland Municipal Stadium. The ground at the stadium was frozen, so during the game Browns' players switched to cleat-less gym shoes to give them better traction on the icy field. The strategy paid off, and the Browns won the game, 30-28. (Courtesy of the Cleveland Press Collection.)

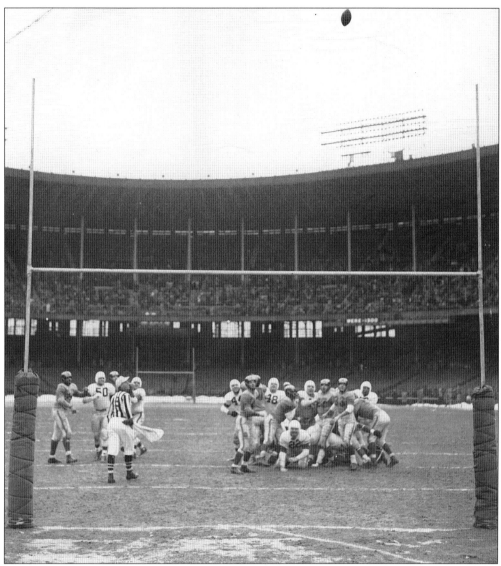

In the 1950 title game, the Browns were down 28-27 with 1:50 left to play. Otto Graham and the offense took the field. Graham led the Browns downfield on a magnificent drive. Graham opened the drive with a 14-yard run, and then completed three consecutive passes totaling 43 yards to get the ball to the Los Angeles 11-yard line. Graham then centered the ball in the middle of the field on a one-yard dive to set up a game winning field goal try. Groza's 16-yard kick (above), aided by a 30 MPH tailwind, split the uprights with 28 seconds left on the clock to give the Browns their first NFL championship. (Courtesy of the Cleveland Press Collection.)

The mental aspect of football was extremely important to Paul Brown. Brown was the first coach to ever diagram plays in playbooks and administer intelligence tests to potential players. Brown's players often spent just as much time on the practice field as they did in the classroom, and if a player failed to learn his playbook, he became a prime candidate for the waiver wire. (Courtesy of the Cleveland Press Collection.)

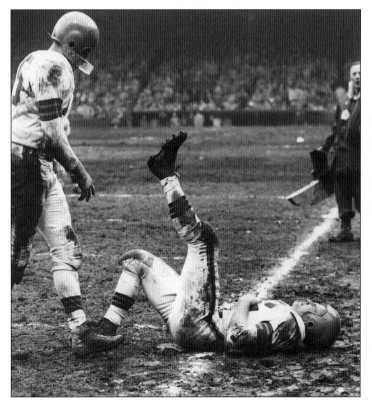

Another innovation that the Browns introduced to the game was the facemask. Len Ford first used the device in 1950. In 1955, Otto Graham took a shot to the mouth that required 30 stitches. Although he returned to the game, he needed to protect the wound while it healed. Equipment manager Morrie Kono devised a flat strip of clear plastic that protected his face but without limiting his vision. The mask immediately became a handle used by defenders to tackle Graham, but rule changes soon outlawed "facemasking." (Cleveland Press Collection, Fred Bottomer.)

Don Shula (left), the NFL's all-time leader in coaching victories with 328 wins, learned the trade as a player with the Browns. Shula, who is originally from Ohio and played for John Carroll University, appeared in 17 games and tallied four interceptions for the Browns as a defensive back in 1951 and 1952. After his playing days, Shula coached the Baltimore Colts for seven years and the Miami Dolphins for 28, winning two Super Bowls. (Courtesy of the Cleveland Press Collection.)

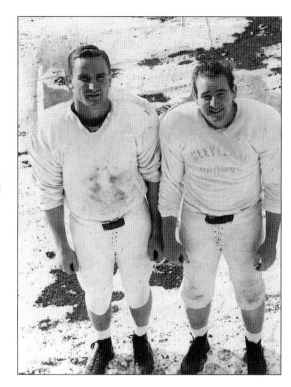

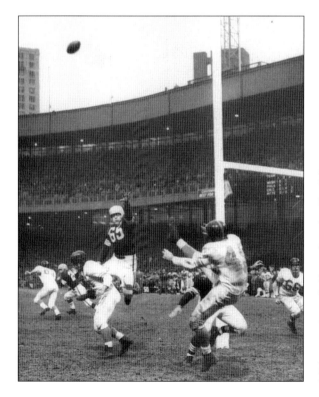

Chuck Noll (#65) just misses a blocked punt against the New York Giants. Noll, another NFL coaching great, also learned coaching from Paul Brown. He spent his entire seven-year career with the Browns as a linebacker and offensive guard before guiding the Pittsburgh Steelers to four Super Bowl championships in the 1970s. Noll coached the Steelers for 23 years, and finished his career with 198 regular season victories and a .667 winning percentage in the playoffs. (Courtesy of the Cleveland Press Collection.)

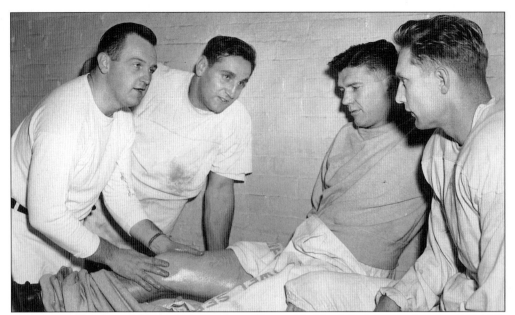

Trainer Leo Murphy (left) rubs down the leg of Browns' halfback Dub Jones after the 1952 NFL Championship game while Lou Groza and Mac Speedie watch. Murphy, hired by Paul Brown in 1950, spent 43 years with the Browns before retiring prior to the 1993 season and was inducted into the National Trainers' Hall of Fame in 1982. (Courtesy of the Cleveland Press Collection.)

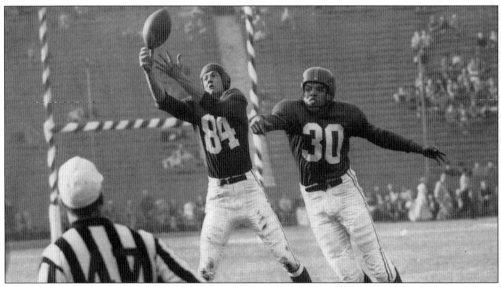

Offensive end Mac Speedie catches a 20-yard pass from Otto Graham in the first annual Pro Bowl game played in Los Angeles in 1951. Speedie overcame a debilitating bone disorder as a child that left him with one leg two inches shorter than the other. Speedie did not let the disease slow him down as he developed remarkable speed and the skill to change speeds and direction, which helped him in to become an outstanding end. Mac led the NFL in receptions in 1952, but left Cleveland after the season and finished his career in the CFL. (Courtesy of the Cleveland Press Collection.)

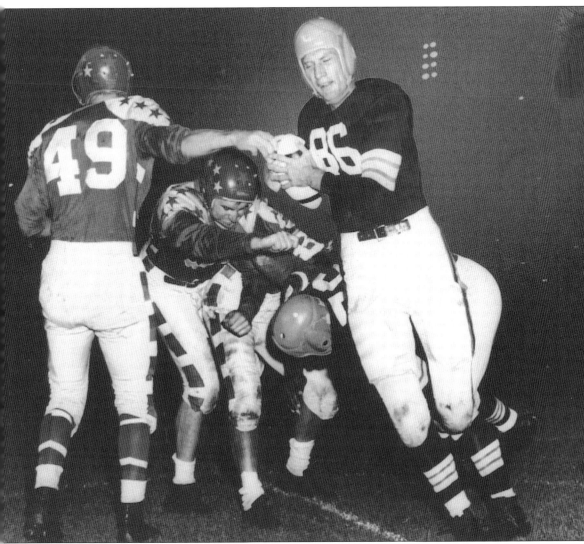

On November 25, 1951, Dub Jones tied an NFL record by scoring all six Cleveland touchdowns against the Chicago Bears in a 42-21 victory. Jones, the Browns' starting halfback, rushed for four of his scores and caught the other two in a 196-yard day. Amazingly, Jones only handled the ball 12 times on that day (nine rushes, three catches), and scored on his last four touches. Late in the game with the Browns winning, 35-7, Jones needed one more score to tie Ernie Nevers' 22-year-old record. Otto Graham audibled out of a running play called by Paul Brown, even though Brown did not allow audibles. Graham hit Jones for a 43-yard scoring pass, giving him a share of the record. "If I had missed that thing, I would probably have gotten chewed out pretty good [by Paul Brown]," remembered Graham. "You didn't want to cross him too often." (Courtesy of the Cleveland Press Collection.)

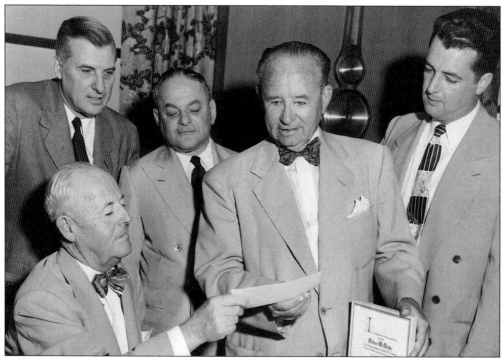

A group of businessmen led by David R. Jones (left, sitting) bought the Browns from original owner Mickey McBride (holding check, standing) in 1953. Jones paid a reported $600,000, and gave McBride a free lifetime pass to all Cleveland home games as part of the compensation. (Courtesy of the Cleveland Press Collection.)

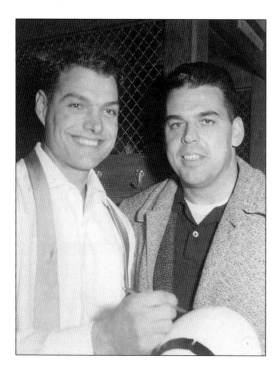

Otto Graham (right) signs an autograph and celebrates after his retirement following the 1955 season. Graham spent 10 years as Cleveland's quarterback, and competed in his league's championship game each season, winning seven of them. Graham was arguably the greatest quarterback in the history of the game, and initially retired after the 1954 season, but came back for one more year at the request of Paul Brown, who never did find his replacement. Graham, a five-time MVP selection, was inducted into the Hall of Fame in 1965, and later coached the Washington Redskins. (Courtesy of the Cleveland Press Collection.)

THREE

Brown In, Brown Out
1956–1962

Otto Graham came back in 1955 at Paul Brown's request to help the team find another quarterback. There were no new quarterbacking options before the 1956 season, so the Browns started with George Ratterman and Vito "Babe" Parilli at the helm. Ironically, Graham's return cost Cleveland one of the greatest passers in league history—Johnny Unitas. Unitas was a ninth round draft choice of the Steelers in 1955, but Pittsburgh cut him at the end of training camp. He contacted Paul Brown and asked the coach for a tryout, but with Graham's return, there wasn't a spot on the team for Johnny. Brown said that he would give Unitas a tryout in 1956, but the Baltimore Colts signed him before that. The bad timing of the situation haunted the Browns for years. Unitas enjoyed a stellar career, and beat Cleveland in two championship games. Meanwhile, Brown never found a suitable replacement for Graham.

Ratterman and Parilli both struggled in 1956, and both went down with injuries mid-way through the season, which started out a disastrous 1-4. Paul Brown turned to Tommy O'Connell, a former Bears quarterback who was cut two games into the 1956 season. O'Connell piloted the Browns to a 4-3 record the rest of the way, but Cleveland suffered its first losing season, finishing 5-7 in the NFL's Eastern Conference.

Brown In: Jimmy Runs to the Top

Another new situation for the Browns was their draft position. For the first time in their history, the Browns would be selecting in the sixth spot. The Browns lost a coin flip with the 5-7 Pittsburgh Steelers, which determined the fifth selection in the draft. Still searching for a quarterback, Brown had his eye on three potential signal callers: Paul Hornung, John Brodie, and Len Dawson. Hornung and Brodie were snatched up right away when Hornung was taken first overall by Green Bay and Brodie went third to the 49ers. The third man, Lenny Dawson, was still available at number five, but the Steelers snagged him right before Cleveland could.

With no other viable quarterbacks available, Paul Brown turned his attention to running back Jim Brown. The fullback's availability at the sixth spot surprised the coach because although he needed a quarterback, he thought Jim Brown was the best player in the draft. When Cleveland's turn came up, Paul Brown did not hesitate to draft the bruising back from Syracuse, figuring that he could get a quarterback somewhere else. That passer was Milt Plum, Cleveland's second round choice of that year.

Jimmy Brown impressed his teammates and coaches right from the start. He was projected to back up Ed Modzelewski at fullback, but those projections were quickly erased. After an all-night drive from Chicago to Cleveland's training camp at Hiram College, Brown got out of his car, put on his gear, and beat the entire team in the 40-yard dash on no sleep. Ed "Big Mo" Modzelewski, the projected starter, knew right then that the starter's job belonged to Brown. Brown took a handoff on a draw play and broke the run for a touchdown during Cleveland's first preseason game. After the play, Coach Brown approached the rookie and simply said, "You're my fullback." Jim Brown would never sit on the bench again; Big Mo's forecast came to pass.

Brown quickly showed the rest of the league why he was the starter in 1957 when he won the NFL rushing crown as a rookie, with 942 yards, and led the NFL with nine touchdowns. The pinnacle of his success came against the Rams in the ninth week of the season, when he rushed for a record 237 yards and four touchdowns, including a 69-yard gallop. His crushing left arm, which he used to straight-arm or beat defenders with, became his signature move while his relentless pursuit of every yard struck fear into his opponents.

With a year of experience under his belt, Jimmy Brown transformed himself into a dominant running machine in 1958. He eclipsed the single-season rushing record held by Steve Van Buren by almost 400 yards, gaining 1527 in just 14 games on the strength of nine 100-yard games. He had an astronomical 5.9-yard average per attempt, and set a record with 17 rushing touchdowns.

Jimmy Brown would continue to dominate the NFL over the next three years. In each year, he led the league in rushing and average, and scored 40 touchdowns in that span. Even though Brown's statistics were impressive, the numbers did not define him. Giants defensive lineman Dick "Little Mo" Modzelewski, the younger brother of Browns fullback Ed, remembered a play when he and seven of his teammates were hanging off of Brown, trying to tackle him. "How can he be dragging us forward?" wondered Modzelewski. Little Mo, like so many other defenders, never saw anyone like Brown, before or after his days in the NFL.

Brown Out: Paul Gets Run Out of Town

As Jim Brown's prestige grew in the league, the team's seemed to fall. Although the Browns rose to the top of their conference in 1957 as they had in their first 10 years, they suffered an awful beating at the hands of the Detroit Lions in the championship game, 59-14. 1958 brought more disappointment to the club when they lost to the Giants in the last week of the season, then were shut out by New York the following week in a playoff game.

By the start of the 1959 season, the Cleveland Browns were not the feared opponent they once were. That 1959 season saw the Browns lose an opening-day game to the weak Steelers, beat up a hapless Cardinals squad, then lose yet another defensive battle to the Giants. The

Browns did get on a roll finally, winning their next five, but a three game losing streak late in the season sealed their second-place Eastern Conference finish with no championship or playoff game.

Part of the problem was that Paul Brown just could not find a quarterback. Ratterman was immobile, Parilli crumbled under pressure, and Milt Plum did not throw the deep ball well. The Browns even traded with Pittsburgh for Lenny Dawson, but he could not crack the starting lineup, and Brown eventually traded him.

Without a solid throwing threat and the ability to stretch the field, teams began to gang up on Jimmy Brown. Although the big man still got his yards, Cleveland's offense was not as dangerous as it once was. Paul Brown began taking heat for this in the press as reporters and fans started to question Brown's play calling in an era when most quarterbacks called their own plays in the huddle. The "messenger system," a set of rotating offensive guards who would relay the plays from coach to quarterback, was an innovation of Brown's in the 1940s.

For the third and fourth consecutive years, Cleveland failed to win the Eastern Conference, finishing second in 1960 and 1961. Even though Jim Brown led the league in rushing both years and Milt Plum had one of the finest passing seasons in history in 1960, Cleveland could only manage to win 8 of 12 contests each year. The complaints about the old coach, who had founded the team 15 years earlier, began to get louder.

David Jones, who bought the Browns from Mickey McBride in 1955, sold the team before the 1961 season to a group from New York City, headed by advertising mogul Art Modell. The $4.1 million price tag was the highest price ever paid for a professional football team. Modell immediately gave Brown a vote of confidence by signing him to a seven-year contract extension upon the completion of the sale. The new owner said that Brown was one of the main reasons he bought the club, and he ensured that Brown would be a part of the franchise for years to come.

Modell, unlike his predecessors, wanted to be involved in the day-to-day operations of the club. Although he made no claim to the final decision making pertaining to football operations, he sought to give Brown input on matters of players, front office personnel, and the like. Brown, who had enjoyed free reign under McBride and the Jones group, saw this as an invasion of his territory and a breach of his contract.

This was never more evident than in the case of the Ernie Davis trade. Brown, acting as general manager, executed the trade that sent Bobby Mitchell to Washington for Ernie Davis. Brown did not notify, much less consult, Modell on this major transaction. Modell found out about the trade when George Preston Marshall, the owner of the Redskins, called Modell to congratulate him on Cleveland's new acquisition. Modell was livid; in his eyes, notification was not too much to ask of Paul Brown. This trade set the tone of what would be a tumultuous relationship between the two leaders of the Browns.

The media added fuel to the Modell-Brown fire. Stories started appearing in the local newspapers about conflicts between the two Browns, Paul and Jimmy. According to published reports, Jim Brown was not happy about the way he was being utilized in Paul's system. Although both men have always denied these reports, the added strain had a detrimental effect on the team.

Jimmy Brown had his worst season in 1962. He failed to lead the league in rushing for the first and only time in his career. He also failed to gain 1,000 yards that season for the first time since his rookie season. The press did not know that Brown badly sprained his left wrist that year. "He couldn't even tie his own shoes," recalled John Wooten, who was Brown's roommate and closest friend on the team. "I always believed that was why 1962 was Jim's worst year." Of course, Jim Brown never missed a game that year. He never even asked to sit out a play, although Coach Brown would rest the ailing back when he could.

The Brown-Modell war continued on through the 1962 season. Brown accused Modell of undermining his authority by organizing player revolts and openly allowing players to break Brown's rules such as not drinking on the road or hosting radio shows. Modell was miffed at

Brown for refusing to allow him to put his own mark on the team.

All the while, the team struggled through the season, finishing 7-6-1, which was only good enough for third place in the Eastern Conference. Brown thought that the team performed well considering Jim Brown's injury, the Ernie Davis tragedy, and the awful quarterback situation. Besides, the coach figured, the team made more money in 1962 than in any year in its history. It was not good enough for Modell, who fired Paul Brown at the end of the season. Paul Brown, the man for whom the team was named, called it "the darkest period of my life."

Brown's dismissal did not stop the bickering between the two men. Modell berated Brown in public relations actions long after he relieved the coach. Modell asserted that Brown did not understand the players of this generation and how to motivate them. He also thought the game of football, which Brown innovated in so many ways, passed the coach by. The owner also claimed that several players approached him and stated they would not return for the 1963 season if Brown remained on the sidelines.

Brown, in his 1979 autobiography, dedicated a chapter to Modell, quoting the owner as saying, "Firing Paul Brown will be my claim to fame," and "as long as you're here, this will never be my team." Brown also insinuated that Modell timed the coach's dismissal with a newspaper strike in Cleveland, limiting the bad press he would receive.

Fallen Soldiers: Tragedy Comes in Threes

Ernie Davis was a high school standout in Elmira, New York, during the 1950s. A three-sport star, he moved to Elmira with his mother from Erie, Pennsylvania, when he was 12 years old and found great success on the football field, the baseball diamond, and the basketball court. Davis was an excellent three-point shooter and led his basketball team on a 52-game winning streak. Scouts in each sport predicted that he had the talent to be a professional in any of them.

In football, Davis was recruited by dozens of schools, but chose Syracuse University due to the campus' proximity to his home. Davis, who succeeded Jimmy Brown, was a very successful fullback for the Orangemen. Unlike Brown, Davis led his Syracuse team to the national championship during his sophomore season. By the time Davis was a senior, he was widely considered the best player in the country. He went into the NFL draft as the favorite to be the first selection taken.

The Washington Redskins held that number one pick, and selected Davis right away. Redskins' owner George P. Marshall was under intense pressure from the league to integrate, and although Davis was black, some speculated that the rookie might not be able to handle the pressure from being the team's first black player.

Cleveland scouted Davis during the past year, under the direction of Paul Brown. Brown knew of Davis' size, athletic ability, and personality, all of which convinced him that Davis would be a force in pro ball. Brown also knew that Jim Brown set a record for rushes in a single season, and wanted a second bruising fullback to share the load. Paul Brown called Marshall and executed the trade that sent star halfback Bobby Mitchell, also a black player, to the Redskins for the rights to Davis.

Bobby Mitchell was a superstar in his own right; he was the lightening to Jim Brown's thunder. His specialties were returning kicks and punts, catching balls out of the backfield, and making defenders miss him with his open-field running and cutting ability. Mitchell was also an NFL veteran, a well-spoken and intelligent man, and a leader. Marshall and Brown agreed that Mitchell was the kind of person who would be able to handle the difficulties associated with breaking the color barrier in Washington. Many experts concurred that this was a good trade for both teams.

The Buffalo Bills of the rival American Football League also drafted Davis. The AFL and NFL were competing leagues, and teams from both often drafted the same players. The teams then competed with each other to sign the players, with the highest bidder winning most of the time. Browns Owner Art Modell ended up winning the bidding war for the young star, in part

by guaranteeing his contract. It was a success for the NFL, and a success for the Browns. Many felt that Ernie Davis would follow Marion Motley and Jimmy Brown in the line of great Cleveland fullbacks.

Just before the College All-Star Game, doctors removed Davis' wisdom teeth. After the surgery, his mouth was just not healing properly, so doctors ran some tests that revealed Davis was suffering from acute leukemia. Doctors gave the budding star just a few months to live.

Davis began treatment, which slowed his disease into brief remission. Through medication and his own will to live, Davis appeared to be getting better, and even started working out for the team. Owner Art Modell publicly speculated that Davis might return sometime in the 1962 season or beyond, but players, coaches, and Davis knew better. Although Davis would try to run laps and perform the calisthenics, he could be seen struggling with his endurance and strength. At one point in the 1962 season, Modell spoke with Brown about letting Davis play in a game. Modell claimed that putting on a uniform and running a play or two might lift Davis' spirits, although Brown suspected that Modell wanted to use the ailing running back as a marketing tool. Brown, citing the unnecessary risk to Davis' health, flatly denied the request. Modell figured that Brown was being stubborn and did not want to risk a precious win, even in a meaningless game.

Ernie Davis never played for the Cleveland Browns; he never even suited up for a game. On May 18, 1963, Davis died in a hospital bed while sleeping. He was 23 years old. The Browns paid tribute to the beloved running back by holding Ernie Davis Day in the fall of 1963, where the team retired his number 45, ensuring that nobody would ever wear it because Ernie never got to.

Unfortunately, the Browns were familiar with heartbreak. Four months before Davis passed away, another rookie tragically died. Tom Bloom, a two-way star at Purdue University, was drafted in the sixth round of the 1963 draft. Bloom was voted the MVP of the 1962 Boiler Makers, and was an excellent halfback, although the Browns drafted him as a safety. In mid-January of 1963, bloom was killed in an automobile accident that also left his former Purdue teammate Tom Fugate paralyzed. Bloom, like Davis, never got a chance to even wear a Browns jersey.

Misfortune struck the Browns one last painful time in 1963. Don Fleming was a promising safety in 1962 with All Pro potential. The third-year veteran was drafted by the Chicago Cardinals in 1958, but chose to return to school at the University of Florida instead of accepting Chicago's offer. Bernie Parrish, a starting cornerback for Cleveland, lobbied with Paul Brown to trade for Fleming. Brown sent a sixth round draft choice to Chicago for the rights to the safety. Fleming slowly began to break into the starting lineup during his rookie year of 1960, and by the end of the year, he was the regular starter at that position. Fleming continued to progress in his pro career, and barely missed All Pro honors in his third year.

Fleming worked during the off-season as a construction worker in Orlando, Florida, as he had each off-season before that. Many of the lesser-paid NFL players found summer jobs as insurance or car salesmen, construction workers, or whatever other jobs they could find because they didn't make enough money as players to comfortably live year-round. Less than a month after Davis died, Fleming and a coworker were electrocuted while on a job, and died on site.

Don Fleming was 25 years old when he died, and was entering the prime of his career. He left behind his wife Rosalie, his son Ty, his best friend Parrish, and an organization of players, coaches and administrators. All were shocked and devastated by his death. Art Modell, all too experienced in matters of this type, paid for Fleming's funeral, and honored Don's memory with a ceremony to retire his number 46.

The Browns went through unfortunate times before 1963, ending with Paul Brown's dismissal. The city of Cleveland has had its fair share of disappointment since, such as the team's move to Baltimore in 1995. Still, the Browns, the city, and the fans never anguished as they did in the summer of '63 when three stars, three family members, were taken from this world in the prime of their lives.

Bob Freeman and George Ratterman pose in training camp before the 1956 season. The two were set to compete for the starting quarterback job vacated by Otto Graham, who retired after the 1955 NFL Championship Game. Both made the team but only Ratterman saw action in a handful of games before Vito "Babe" Parilli replaced him in the lineup. The Browns never found a suitable replacement for the all-world Graham, and suffered through their first losing season in 1956. (Courtesy of the Cleveland Press Collection.)

Marion Motley, Cleveland's All Pro fullback, ended his career as a member of the Pittsburgh Steelers. Paul Brown expected Motley to retire after the 1954 season, but to his surprise, Motley reported to training camp when it opened for the 1955 season. Multiple knee surgeries rendered Marion ineffective as a runner, so Brown traded Motley to the Steelers so he could continue playing. Motley found out about the trade in the press; Brown admitted he handled the situation badly, saying that he wished he could do it over again. The two eventually made amends. (Courtesy of the Cleveland Press Collection.)

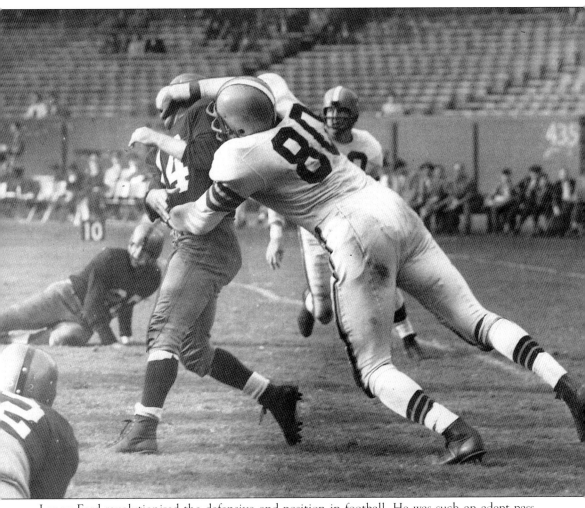

Lenny Ford revolutionized the defensive end position in football. He was such an adept pass rusher that Paul Brown switched Cleveland's defense from a six-man line to a four-man line, inventing the modern-day 4-3 scheme. Lenny could have revolutionized the tight end position as well, though. Before coming to the Browns, Ford was an outstanding receiver for the Los Angeles Dons, but because of the offensive talent on the Browns, gave up the position to focus on defense. Lenny finished his career with a then-NFL record 20 fumble recoveries. (Courtesy of the Cleveland Press Collection, Filkins.)

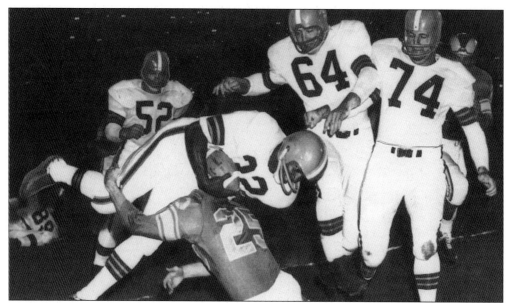

Cleveland drafted Jimmy Brown (#32) with the sixth overall pick in the 1957 NFL Draft, and the bruising fullback paid immediate dividends. Brown's crushing left stiff-arm enabled him to lead the league in rushing during his rookie year on the strength of his record-breaking 237-yard outburst against the Rams at the end of the season. In his second year, Brown demolished the single-season records for yards and touchdowns as well. (Courtesy of the Cleveland Press Collection.)

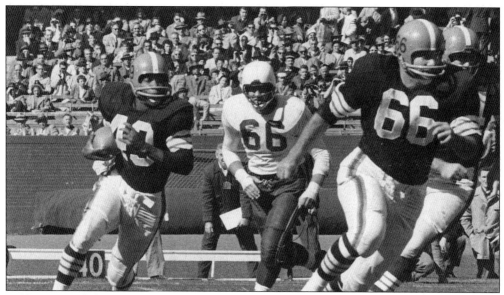

Bobby Mitchell (#49) was Cleveland's starting halfback, and the lightening to Jim Brown's thunder, from 1958 through 1961. Paul Brown would pound Jimmy inside, then sweep Bobby on the outside in a scheme that no NFL defense could defend. Mitchell was also an excellent returner, scoring the first punt and kickoff returns for touchdown in Browns' history. Brown traded Mitchell for Ernie Davis before the 1962 season, and Bobby continued his Hall of Fame career with the Washington Redskins as a receiver. (Courtesy of the Cleveland Press Collection, Fred Bottomer.)

A pair of Browns run in conditioning drills during training camp in 1959. One test that Paul Brown invented to gauge a player's skill was the 40-yard dash. Though 40 yards was a seemingly odd distance, Brown used 40 yards, rather than 50 or 100, because the average punt in pro football travels that far. Brown figured that young players looking to make the squad would participate on special teams, and the 40-yard dash was a good indicator of a man's "game speed" since players hardly ever ran the full length of the field on one play. (Courtesy of the Cleveland Press Collection.)

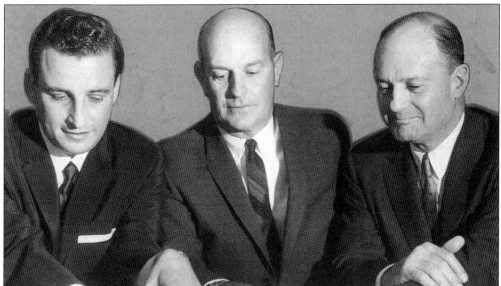

Arthur B. Modell (left) and R.J. Schaefer (right) purchased the Browns from David Jones on March 23, 1961. Modell, an advertising executive from New York, financed the $4.1 million deal through loans acquired from New York banks. Although Modell extended Paul Brown's contract for eight years, Brown (middle) would only last with the club for another two seasons. Modell fired Brown at the close of the 1962 season in which the Browns finished 7-6-1. The owner hired Brown's long-time assistant, Blanton Collier, to replace him. (Courtesy of the Cleveland Press Collection.)

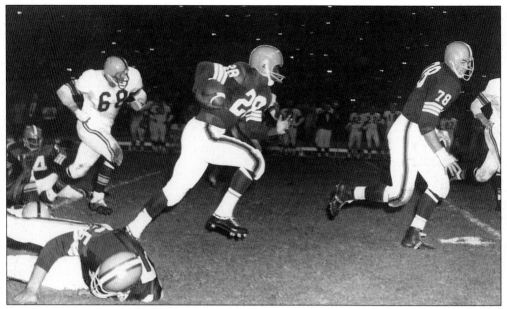

Ernie Green, seen with the ball here, was a bruising fullback for the Browns during his seven-year career. Green rushed for over 4,000 yards, averaging almost 5 yards per attempt, and he had outstanding hands out of the backfield, especially for a big man. His main job with the Browns, though, was the lead blocker for Jim Brown. From 1963 to 1965, Brown rushed for almost 5,000 yards and averaged over 5.6 yards per attempt behind Green's devastating blocks. Green blocked for three Hall of Fame backs in his career: Brown, Bobby Mitchell, and Leroy Kelly. (Courtesy of the Cleveland Press Collection.)

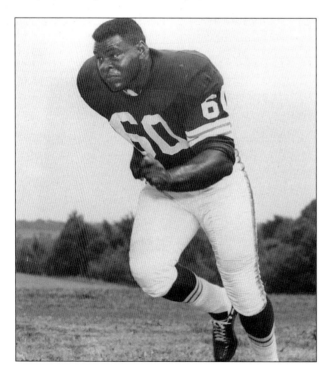

John Wooten was an outstanding offensive guard for the Browns, and was Jim Brown's roommate and best friend. Although he was a two-time Pro Bowl player, many fans remember him for a racial dispute he had with teammate Ross Fichtner in 1968. Wooten accused Fichtner of racism when he was not invited to the safety's golf outing. The story erupted in the local media, the team released both players, and neither saw significant NFL action again. Wooten later surfaced as a player agent, and then as a scout with the Dallas Cowboys. (Courtesy Cleveland Press Collection, Henry M. Barr.)

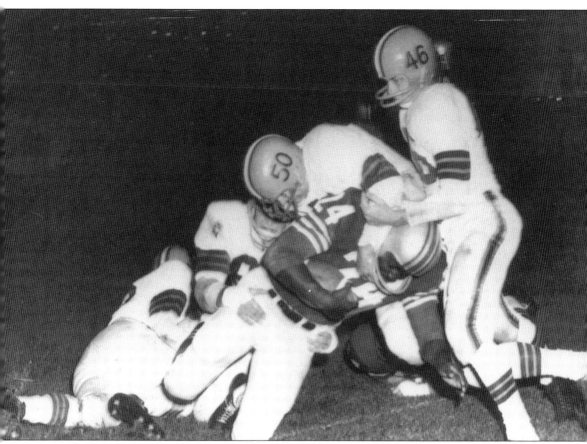

Don Fleming (#46) was an overachieving defensive back from the University of Florida, and although he enjoyed a fine career with the Gators, he never thought about playing professional football. The Chicago Cardinals drafted Fleming in the 28th round with the 327th overall choice in 1959, but the young safety decided that he would not report to Chicago. His friend and former Florida teammate, Bernie Parrish, was an established starting cornerback with the Browns and convinced Paul Brown to take a look at Fleming. Brown traded for Fleming, who ended up with a roster position. Fleming worked his way into the starting lineup by the 1960 season, and by 1963, he was a budding All Pro safety. Tragically, Fleming and a coworker died during an off-season construction accident before the 1962 season. The Browns retired Fleming's number 46 jersey in a solemn ceremony conducted during the 1963 season. (Courtesy of the Cleveland Press Collection.)

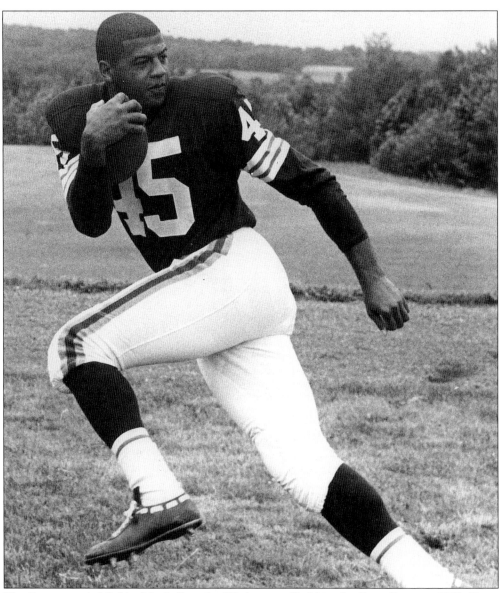

The Browns traded Bobby Mitchell to the Washington Redskins for Ernie Davis in 1962. Davis was a bruising back who broke all of Jim Brown's records at Syracuse University, and Paul Brown envisioned a backfield with both men when he executed the trade. That backfield never materialized, though, because days before training camp opened in 1962, doctors diagnosed Davis with acute leukemia. This promotional photograph represents the only time Davis ever suited up in his #45 Browns uniform. Davis died within the year, and the Browns, as they did with Fleming, retired Davis' number the following year. (Courtesy of the Cleveland Press Collection.)

Four

A Franchise Reborn

1963–1970

1964 NFL Champions

Less than two years after buying the Cleveland Browns, Art Modell fired head coach Paul Brown. Brown was extremely popular with fans despite the team's struggles in 1962, and even though area newspapers were on strike during the time, Modell knew that there would be backlash on the television and radio airwaves. A fast hire would quell the looming public relations disaster, but that hire needed to be not only a good coach, but also a popular figure.

Modell had two candidates in mind before he even announced Brown's dismissal. One was former quarterback and Paul Brown protégé Otto Graham, who was coaching at the Coast Guard Academy. The other was current assistant Blanton Collier, who was very popular with Browns players. Cornerback Bernie Parrish claimed that Modell asked him to poll the team on their preference between the two, and according to Parrish, Collier won by a 3-1 margin.

In truth, Modell probably decided on Collier notwithstanding Parrish's alleged survey. Even though Graham would have satisfied nearly all of the fans and media, he was a demanding taskmaster like his mentor, Paul Brown. He was also one of the team's most important historical figures, making him less attractive to Modell, who wanted to put his own mark on the team. When asked later, Graham said that he would not have taken the job anyway, out of respect for his former coach.

Art Modell announced Blanton Collier as the new head coach of the Cleveland Browns one day after he fired Brown, and the team retained all of the Brown's assistants. The fans and media met the decision with lukewarm approval. Collier held various assistant coaching positions with the Browns dating all the way back to 1946, and his proclamation that Paul Brown encouraged him to accept the job put many at ease, even though Paul Brown later denied Collier's statement.

Blanton and the Browns Rise to the Top

Most experts predicted a tumultuous, last-place year for the Browns. Not only was Brown gone, but the team also suffered through the off-season deaths of Don Fleming, Ernie Davis, and Tom Bloom. There was not a clear-cut starting quarterback in place, as Jim Ninowski and Frank Ryan would compete for the job in training camp. Mike McCormack and Jim Ray Smith were gone, leaving the Browns with only 60 percent of their starting offensive line.

In order for Art Modell to get past the Paul Brown situation, the Browns needed to defy the odds and get out of the blocks quickly in 1963, and anything less than eight wins would put Modell on the hot seat in Cleveland. Jim Brown had to return to his pre-1962 form as well. Much of the media's attention in 1962 focused on the poor relationship between Brown and Brown, and although Jim's wrist injury was the culprit for his poor season, those outside of the organization attributed it to play calling.

Both Collier and Brown delivered in spectacular fashion, starting with their very first game against the Redskins. Collier, who gave the starting quarterback job to Frank Ryan over Jim Ninowski, saw the decision pay dividends in week one; Ryan threw for over 300 yards as the Browns racked up over 500 yards in a 34-17 win over Washington. Jim Brown accounted for almost 300 of those yards, rushing for 162 and catching passes for over 100 more.

The Browns proved that their opening week performance was no fluke as they rattled off five more wins in a row. Collier's offense, led by Brown and Ryan, ripped off 35 or more points in each win except for a 20-6 victory against the Rams. In week six, Brown broke Joe Perry's record and became the league's all-time leading rusher with 8,385 yards. Frank Ryan enjoyed his best year as a pro as well; he finished the year with a spectacular 90.4 quarterback rating, one of the highest in league history at that time.

In week seven, Cleveland's archrival, the New York Giants, came to town and ended the Browns' perfect season by demolishing them, 33-6. That loss seemed to turn the momentum of the whole season. The rest of the league figured out how to stop Cleveland's potent attack, and the Browns did not score 30 points in a game for the rest of the season. The Browns finished 10-4, which was only good enough for second place in the Eastern Conference.

Even with Cleveland's sixth consecutive non-championship year, few were calling for Paul Brown's return. Ryan threw 25 touchdown passes and narrowly missed his first Pro Bowl. Brown broke his own single season rushing record, gaining 1863 yards; he also led the league in average (6.4 yards per rush) and touchdowns (12).

In order to make a serious run at the championship, the Browns had to improve their average defensive unit, especially the line that did not consistently pressure opposing quarterbacks. The Browns traded little-used receiver Bob Crespino to the Giants for defensive tackle Dick "Little Mo" Modzelewski, the brother of former Browns' fullback Ed, which allowed the athletic but smaller Jim Houston to move to linebacker. Starting receiver Rich Kreitling became expendable when the Browns drafted Ohio State standout Paul Warfield, and Kreitling was traded for more defensive help. The Browns felt they had the pieces in place to make another championship run, even if the national media disagreed.

For the second straight year, the Browns shocked NFL prognosticators everywhere as they led their division from the start. Only a Saturday night loss to the Steelers prevented the club from staying in first place throughout the entire season. Still, as the 13th week of the season approached, the Eastern Conference title was still in doubt. The 7-3-2 Cardinals, who tied the Browns in week two, hosted the 9-2-1 Browns, and found themselves one and a half games behind Cleveland with two to play.

The Cardinals broke the game open in the second quarter, capitalizing on a couple of key Cleveland miscues. St. Louis quarterback Charley Johnson first threw a pass to Joe Childress, who broke a tackle and scored from 46 yards out which gave the Cards a 7-3 lead. St. Louis intercepted Ryan on the ensuing possession, leading to another Cardinal touchdown. They added a third touchdown minutes later and led the Browns, 21-6, at the half.

The Browns trailed, 28-9, going into the fourth, but Lou Groza kicked his fourth field goal of

the game early in the period to cut into the deficit. Right after the kickoff, defensive end Paul Wiggin recovered a Cardinals' fumble, leaving the Browns just 18 yards from a touchdown. The comeback attempt died quickly when Ryan threw another interception, this time in the end zone. Even with the loss, the Browns clinched the East on the last week of the season by demolishing the last place Giants, 52-20 in New York.

The Browns prepared for the Baltimore Colts, winners of the Western Conference, on December 27, 1964. The Colts finished 12-2 on the power of an 11-game winning streak during the season. Johnny Unitas' offense, based on short timing passes to ends Raymond Berry and Jimmy Orr and the running of Lenny Moore, was nearly unstoppable. Unitas passed for almost 3,000 yards in 1964, and Moore set an NFL record with 20 touchdowns.

Hardly anyone in the local or national media gave the Browns much of a shot in the title game; they were 17-point underdogs when the game started. Even though Cleveland's offense piled up big numbers, the defense failed to pressure opposing quarterbacks all season long. If they could not get to Unitas in the title game, he would pick them apart downfield. Even if they could, the Colts' receivers still figured to handle the secondary with ease.

Cleveland's defense bucked the conventional wisdom of other NFL squads; they decided to play bump-and-run coverage on the outside, although most of Baltimore's opponents backed way off Berry and Orr, allowing them to run timing patterns five or more yards further up the field. Along with bump-and-run, Cleveland linebackers dropped back using deeper angles, forcing Unitas to throw quicker than he wanted to. The line also switched to the "Brown Defense," which overloaded the weak (off-tight end) side of the offense to open up different pass-rush lanes. Cleveland hoped that these adjustments disrupt the timing of the Colts' passing offense

This strategy worked to perfection, as evidenced on the very first pass play. Orr ran a square-in route that he had to break off earlier than planned due to the coverage. When Unitas looked up to throw, he saw linebacker Jim Houston, who dropped back on a deep coverage angle, in his way, and he had to tuck the ball and run with it, gaining seven yards instead of 15 on an uncontested pass play.

Cleveland's defense shut down the Colts for much of the first half, but the Browns' offense was disappointing, and neither team had scored by half time. Baltimore took the opening kickoff in the third period, but punted three plays later. The short punt into the wind set the Browns up with good field position that Lou Groza converted into a field goal and a 3-0 lead. That breakthrough inspired the defense, who forced another Baltimore punt. A 46-yard Jim Brown run set Cleveland up with first-and-ten from the Baltimore 18-yard line. Frank Ryan hit Gary Collins on a post pattern for the touchdown and a 10-0 lead as the Browns assumed total control of the game.

The same pattern repeated itself for the rest of the game. The defense contained Unitas, and Ryan threw scores to Collins. By the time the dust settled, the Browns piled up 27 points on the strength of three Ryan-to-Collins touchdowns and two Groza field goals. Meanwhile, Cleveland held Baltimore's vaunted offense to an amazing zero points and the great John Unitas to a pedestrian-like 95 yards passing.

The win was redemption for players like Bernie Parrish who worked so hard to get rid of Paul Brown. Likewise, Blanton Collier finally proved that he was a great coach in his own right, not just another piece of Brown's system. Finally, Art Modell felt vindicated that he made the right choice in firing Brown and relieved that his detractors could no longer point to that decision after every loss. The team not only succeeded, but also rose to the top two short years after Paul Brown left. Few, if any, predicted such a feat.

In 1965, The Browns proved that the championship was not a fluke. They blew through the regular season, going 11-3, and won the East by four games. Meanwhile, the Colts and the Packers wound up tied at 10-3-1 tie in the West. Green Bay stumbled in last week of the season to open the door for Baltimore, but won their conference in a playoff with Baltimore.

The run-oriented Packers surprised everyone at Lambeau Field when Bart Starr came out

throwing to open the game, and it paid off when Carroll Dale hauled in Starr's pass for a 47-yard score. Cleveland retaliated on a Ryan-to-Collins touchdown pass to cap the ensuing drive, marking the fourth touchdown in championship play for the duo. The PAT failed, but Groza booted a short field goal to put Cleveland on top, 9-7, after one quarter.

The teams traded field goals in the second, and Green Bay led, 13-12, at halftime. Vince Lombardi put away the pass plays in the second half as the Packers pounded the ball for another 10 points while holding the Browns scoreless. The Packers foiled Cleveland's bid for a repeat championship performance, and the game was not as close as the 23-12 final score indicated. The Packers held Jim Brown to just 50 yards while their offense gained over 200 rushing yards.

Green Bay coach Vince Lombardi acquired much of the talent on his 1961, 1962, and 1965 championship teams from the Browns. He was good friends with former Cleveland coach Paul Brown, and Brown used to trade players to the Packers that could not crack his lineup. Brown would also call Lombardi whenever he cut a player so Vince could have the first crack at him. Two major players on the tough Green Bay defense, Willie Davis and Henry Jordan, started out in Cleveland. Babe Parilli, traded away in 1957, mentored Green Bay's young quarterback, Bart Starr.

The Browns entered the 1966 season with high expectations based on their two previous years. However, a major setback to their plans occurred as training camp opened for the year. All-World fullback Jim Brown was not there. Filming on his first feature movie, *The Dirty Dozen* ran very late, and he was still in England taping the film. Brown's absence irratated Art Modell, so he took a hard-line stance to get his superstar back to Cleveland by fining Brown for each day he missed. Brown decided to retire from pro football instead of paying the fines.

Brown's retirement sent shock waves through the media, the fans, and the NFL. Jimmy Brown was in the prime of his career with a title-contending team, and he apparently gave it all up to make movies. Brown later stated that football was only one part of his life, and he alleged that he planned to retire soon anyway. Still, Art Modell used the fullback as the driving force to fire Paul Brown, and now it appeared that he drove Jimmy Brown out, too. These two incidents made Modell a villain, despite the team's recent successes.

Brown's replacement, Leroy Kelly, rushed for almost 1,200 yards, and Frank Ryan threw 29 touchdown passes. After a 1-2 start, Cleveland climbed back into the Eastern Conference race, but lost to the Eagles in week 13 to fall out of contention. The Browns finished a respectable 9-5, found their running back of the future, and made the best of a bad situation.

New Division, New Rivals, New Hope

The 1967 season saw many changes to the NFL and professional football. The Eastern Conference was split into two divisions (Capitol and Century), as was the West (Central and Coastal). The winners of each division would meet to decide the conference champions. Those champions would then play for the NFL title. Finally, after seven years of competing with the AFL, the NFL champion would play the other league's champion in a title game.

The new divisional format worked out well for Cleveland. The Giants, Steelers, and Cardinals did not put up much of a fight for the divisional crown, and the Browns easily won the Century Division by two games with a paltry 9-5 record. The Browns matched up with the 9-5 Cowboys, winners of the even weaker Capitol Division, in the first round of the playoffs. The Browns were thoroughly whipped, 52-17, and were dominated in all areas of the game as the Cowboys took advantage of every Cleveland mistake.

The Century Division remained weak in 1968 despite a minor realignment. The Giants moved to the Capitol Division and the Saints took their spot in the Century. Again, Cleveland and Dallas won the two divisions and met in the playoffs for the Eastern Conference crown. This time, the Browns took advantage of all of Dallas' mistakes, converting five turnovers into 24 points, and easily won, 31-20. The Browns avenged their embarrassing loss from a year before and earned the right to play for the NFL title and a trip to Super Bowl III.

The Western Conference winners, the Baltimore Colts, wanted a little revenge themselves. After the Browns thoroughly trounced them in the 1964 title game, Don Shula's Colts knew to take Cleveland's threat seriously. Although the game started out promising for the Browns with an early offensive push, Don Cockroft's field goal attempt was blocked. Baltimore scored 17 in the second quarter, and then eventually doubled that before the final gun, while Cleveland never got close to the end zone. The Colts handled the Browns to the tune of 34-0, marking only the second shutout of a Cleveland Browns offense in team history.

It was one of the greatest victories for the Colts in team history, but the jubilation was short-lived as the Colts lost to the New York Jets of the AFL in Super Bowl III, despite entering the game as the prohibitive favorite. Just two weeks after earning what should have been his greatest coaching victory, Baltimore fired Don Shula.

Although many of the stars from the 1964 title game like Brown and Groza were gone, a veteran core of players remained. Gene Hickerson, Dick Schafrath, and Monte Clark continued to anchor a superior offensive line. Gary Collins and Paul Warfield remained at wide out, and Leroy Kelly was a superstar at fullback. Once again, Browns fans expected big things from their club.

The Browns' first two games featured big running days from a couple of bench players. Ron Johnson rushed for 118 yards against the Eagles in a week one victory where the Browns led throughout the day and finish off Philadelphia, 27-20. In week two, Reece Morrison gained 131 in a come-from-behind win against Vince Lombardi's Redskins, Cleveland's only win against the legendary coach. The key play was a Nelsen-to-Collins touchdown pass with a minute left. The Browns traveled to Minnesota after a 42-10 win against the Cowboys. Cleveland sported a 5-1-1 record, best in their division. The Vikings led the Central Division with a 6-1 record on the strength of their "Purple People Eaters" defense, but Minnesota's offense racked up 51 points, scoring nine times in 10 possessions to hand the Browns their worst defeat in team history, 51-3. The Browns bounced back, though, and rattled off four consecutive wins on the heels of that loss. Cleveland finished the season with a 10-3-1 mark, and met the Cowboys in the 1969 Eastern Conference Championship Game.

The rubber match of what became the annual Dallas-Cleveland playoff series unfolded just like the first two; one team trounced the other by making the most of turnovers. For the second year in a row, the Browns dominated the game by opening a 17-0 lead in the first half and won the game going away, 38-14. Unfortunately for Cleveland, the Vikings beat the Rams, 23-20, in Los Angeles, so the Browns would have to travel to frozen Minnesota, the site of Cleveland's 51-3 loss, for the NFL Championship Game.

Much like the regular season match up, this game was no contest. Minnesota had 17 points on the board before Cleveland could find a rhythm. Vikings Quarterback Joe Kapp scored on a seven-yard run and then threw a touchdown from 75 yards out to Gene Washington. Minnesota had a 24-0 lead at halftime, and finished off the Browns by a final score of 27-7.

One Last Run for the Old Man

Cleveland's loss closed the NFL's golden era, as the AFL and NFL began playing as one league in 1970. Twenty years before, a 35-10 Browns victory over the vaunted Eagles opened that era in spectacular fashion. In between, Cleveland won four championships, participated in another eight championship games, and played in the post-season 15 total times. It was a successful time for the Browns, the NFL, and professional football.

As a part of the merger agreement, the AFL clubs would form the American Football Conference, and the NFL teams would be in the National Football Conference with three exceptions. One obstacle in this agreement was the fact that the NFL outnumbered the AFL in teams, 16-10. None of the older league's clubs wanted to move to the AFL side. This point almost destroyed merger talks altogether, but Modell convinced the owners of the Steelers and Colts to come over to the AFC with him. They did, the leagues merged, and the NFL changed

forever.

Another idea that Art Modell proposed during the merger was the creation of a Monday night national television game each week. Modell figured that the national exposure would be good for the game and an additional television contract could put more money in the NFL coffer. That contract went to ABC, and they employed the team of Howard Cosell, Don Meredith, and Keith Jackson as the on-air personalities. Modell was rewarded with hosting the first-ever Monday Night Football game in Cleveland—against Joe Namath and the Jets.

The new format was a ratings success, and the game was a very good one. Cleveland took the opening kickoff and drove 55 yards down the field for a touchdown. They scored again in the first on a two-yard run by Bo Scott, and never looked back. Despite opening a 21-7 lead in the third, the Jets fought back, and found themselves down by just three points in the fourth with the score 24-21. Namath attempted a comeback, but Billy Andrews intercepted him and returned it for a touchdown, sealing the game for the Browns. The final score was 31-21.

The Browns and Steelers from the NFL formed the AFC Central Division with the Houston Oilers and Cincinnati Bengals of the AFL. This was significant to fans, the local media, and Art Modell because Paul Brown founded the Bengals in 1968, and served as their head coach as well, which meant that Brown would return to Cleveland as the opposing coach in week four.

The Browns split their next two games, losing a thriller to the 49ers, 34-31, and then struggling free from the Steelers, 15-7. Cleveland's 2-1 start hardly seemed relevant to their fans because it was week four, and time to face the man who built the Browns tradition: Paul Brown. The Bengals proved to be every bit as tough as their gritty old owner/coach.

Cincinnati opened the scoring with a 50-yard field goal, and followed that up later in the first with a short touchdown run. The fans were surprised at the 10-0 deficit, but not completely stunned. Cleveland's defense sparked the team later in the first with a safety, and the offense followed that up with a touchdown drive and short payoff pass to Leroy Kelly, which cut the deficit to one. The teams traded touchdowns before the half, and the Bengals led, 17-16, at the intermission.

The game remained close through the third and into the fourth with Cincinnati extending its lead to four. The Browns finally took the lead then sealed the victory with a pair of one-yard rushing scores late in the game. The Bengals scored one last touchdown in the closing moments, but by that time, it was too late; the final score was 30-27.

Perhaps the most significant moment of the game came after the final gun sounded. Paul Brown ran straight to the locker instead of greeting Collier at midfield amid a chorus of boos from the Cleveland faithful. Brown later downplayed the incident, claiming that he had not practiced the ritual in years.

Collier spoke to Modell during training camp in 1970 and told the boss that he would retire after the season, regardless of how the team finished. He was concerned about his degenerative hearing loss, which over the years nearly left him deaf in one ear. He announced his decision to the media before a week 12 contest in Houston.

The Browns won two of their last three after the announcement, but that was only good enough for a 7-7 record and second place in the new Central Division. First place belonged to Paul Brown's Bengals, who won their last three to eek out the division crown. The eventual Super Bowl IV Champion Baltimore Colts shut out the Bengals in the first round of the playoffs, 17-0.

The win against Brown capped Collier's transformation in Cleveland. The man who started out as a humble student became a protégé and eventually a champion in his own right. He beat his teacher and became a hometown hero, solidifying himself as a legend. He then gracefully bowed out on his own terms, a rarity for coaches before or since.

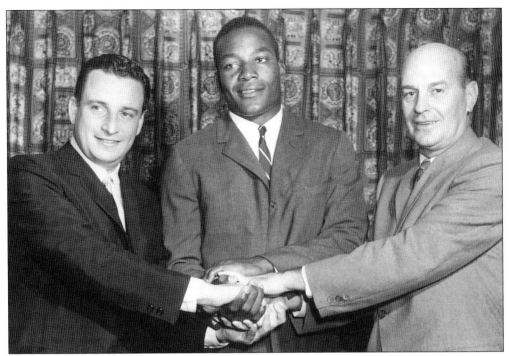

Modell, Jim Brown, Paul Brown, pictured from left to right, pose for a photo opportunity in March of 1962. Paul Brown only lasted nine more months as Cleveland's head coach as Modell fired him after the 1962 season. Upon Brown's dismissal, Modell claimed that Brown would remain with the club as personnel evaluator and advisor, but the team did not take Brown's advice. Brown quietly left the team after Modell agreed to pay the balance of his contract and buy back his shares of the team. (Courtesy of the Cleveland Press Collection, Fred Bottomer.)

Blanton Collier (right, front) took over as the head coach of the Cleveland Browns one day after Modell fired Brown. Collier, who coached the University of Kentucky from 1954 to 1961, was only with the team for one year prior to his promotion, but longtime Browns fans remembered Collier as an original member of Paul Brown's staff. Prior to his stint at Kentucky, Collier assisted Brown with defense and quarterbacks from 1946 to 1951. In this photo (taken in 1951), Collier shows proper defensive technique to a young player during training camp. (Courtesy of the Cleveland Press Collection.)

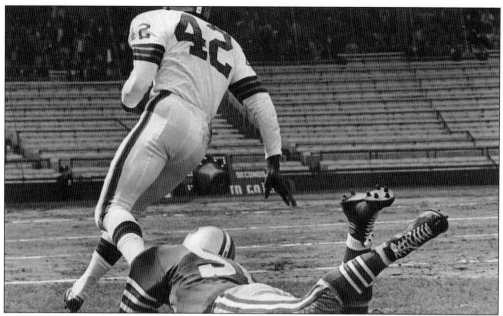

The Browns chose Paul Warfield (#42) with their first pick in the 1963 draft. Warfield, a standout wide receiver at The Ohio State University, was one of the fastest receivers in team history and provided the deep threat that the Browns lacked during the early 1960s. In the 1964 NFL Championship Game, Warfield often drew double-coverage, which freed his counterpart Gary Collins to catch three touchdowns in the game. Warfield caught 215 passes and 44 touchdowns for the Browns between 1963 and 1969. (Courtesy of the Cleveland Press Collection.)

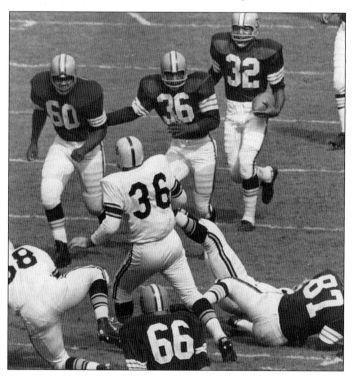

In a familiar sight to Browns fans of the 1960s, Jim Brown runs behind his line, one of the best in NFL history. Leading the way are Larry Stephens (#68), John Wooten (#60), and Jamie Caleb (#36), while Gene Hickerson (#66) and Fred Murphy (#87) have already finished off their blocks. Not pictured are tackles Mike McCormack and Dick Schafrath. Only McCormack reached the Hall of Fame, while Schafrath and Hickerson are often considered two of the best linemen not enshrined. (Courtesy of the Cleveland Press Collection.)

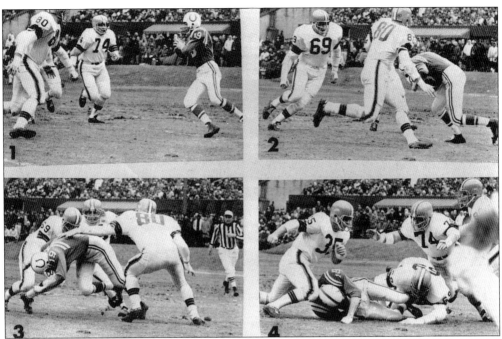

Johnny Unitas drops back to pass, but Bill Glass (#80) and Dick Modzelewski (#74) are there to greet him immediately. Unitas has to tuck the ball and run, but Jim Kanicki (#69) is there to clean up the sack. Cleveland entered the 1964 NFL Championship game as 17-point underdogs against to the Colts because of their weak defense, but that defense came through in the game as linemen harassed Johnny Unitas all game long, and the secondary's bump-and-run coverage disrupted the timing-based pass routes. (Courtesy of the Cleveland Press Collection.)

Gary Collins catches one of the three touchdowns he scored in the 1964 title game. The game was almost cancelled; players from both teams planned to strike hours before the contest. The players petitioned the league to place a portion of the gate receipts from the game into the players' pension fund, but owners instead placed the money into a pension fund for front office personnel. Bernie Parrish, the Browns' labor activist, tried to convince Ordell Brasse of the Colts to sway his team to strike. They refused, and the game was played. (Courtesy of the Cleveland Press Collection.)

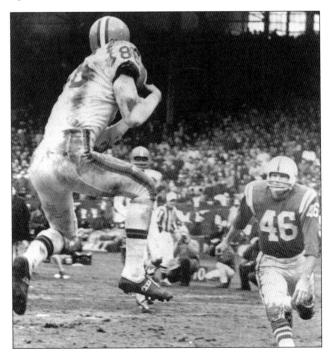

Gary Collins stretches over the goal line for a touchdown! The Browns shocked the world by destroying the Baltimore Colts, 27-0, in the 1964 NFL Championship game. Collins caught 5 passes for 130 yards and three touchdowns, and earned the Most Valuable Player award for his efforts. Along with his five catches, Collins also punted three times for a 44-yard average. Jim Brown rushed for 114 yards in the game, and his 46-yard romp in the third quarter set up one

of those touchdowns. The defense performed valiantly, forcing two Johnny Unitas interceptions and sacking the great Baltimore quarterback two times. After starting out five-for-five in the first quarter, Unitas only completed seven throws for the rest of the game, which enabled the Browns to win the field position battle and allowed the offense to get on a roll in the second half. (Courtesy of the Cleveland Press Collection.)

As in virtually every other home game, fans packed Municipal Stadium to capacity for the 1964 title game. The only tickets remaining the day before were a few hundred standing-room-only spots. Even though the NFL considered the game a sellout, Art Modell refused to broadcast the game on Cleveland television, forcing tens of thousands of Browns fans to listen to the game on the radio. The team finally televised the game on Monday, but Modell's reputation took a sizeable hit with angry fans. (Courtesy of the Cleveland Press Collection, Fred Bottomer.)

The Browns clinched the Eastern Conference championship for the second straight year, and prepared for the 1965 title game. In the Western Conference, the Packers and Colts tied for the lead, forcing a playoff between the two clubs. Unsure of which team they will face, Jim Kanicki (#69) and Jim Houston (#82) decide to cover both possibilities while Bill Glass (#80) expresses a popular political agenda. The Packers beat the Colts in the playoff, and then beat the Browns for the 1965 championship. (Courtesy of the Cleveland Press Collection.)

Jim Brown and Y.A. Tittle were the first co-winners of the Most Valuable Player award in 1963. The award, called the "Jim Thorpe Memorial Trophy" and awarded by the Newspaper Enterprise Association, was Brown's second. Tittle, a standout quarterback for the Giants, started his pro career with the Browns in the AAFC, but Cleveland lost him to the Baltimore Colts in 1948. Brown again won the award after the 1965 season, his last year in the league. (Courtesy of the Cleveland Press Collection.)

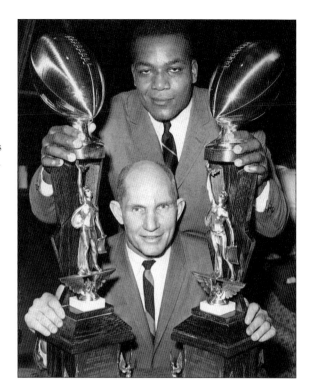

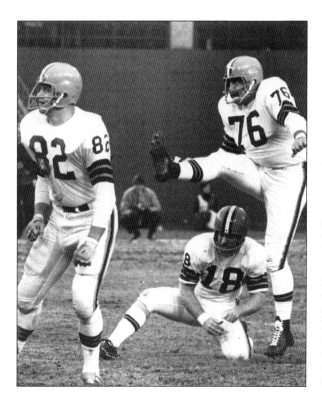

Lou Groza kicks one of his 810 career extra points in a 55-7 loss to the Packers. Groza retired after the 1967 season as the last original member of the 1946 Browns and the all-time professional scoring leader with 1608 points. Lou, an excellent lineman until 1959, originally retired in 1960 with back problems, but returned to the team as a kicker only upon the request of Art Modell. Groza passed away in 2000, and the Browns paid final tribute to him by changing the address of its team offices to 76 Lou Groza Blvd. (Courtesy of the Cleveland Press Collection, Paul Tepley.)

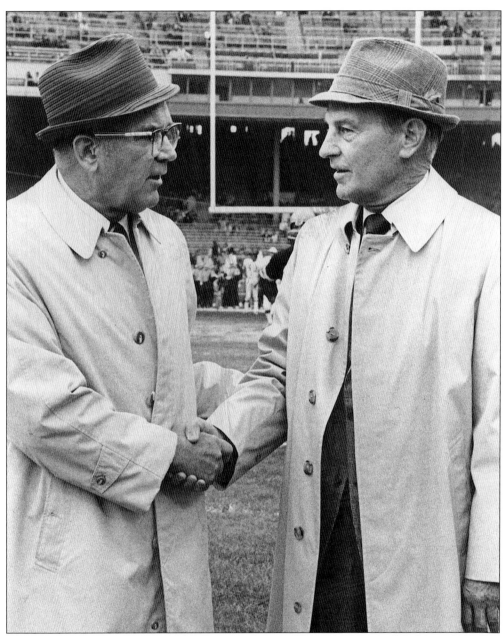

Paul Brown retired to California after his 1962 dismissal from the Browns, but later returned to Ohio and founded the Cincinnati Bengals in 1968. The Bengals played in the American Football League during their first two years, but later joined the NFL when the two leagues merged in 1970. The Browns and Bengals became divisional rivals under the new alignment, and they met for the first time on October 11, 1970, in Cleveland Municipal Stadium. Cleveland won the game, 30-27, but Browns fans became upset when Brown did not meet Cleveland coach Blanton Collier afterwards to shake hands. Although the fans were upset, Brown had not practiced the handshake ritual for years. Brown *did* meet with Collier before the game where the two shook hands, captured in this photo, and engaged in a short conversation. (Courtesy of the Cleveland Press Collection, Paul Tepley.)

FIVE

Peaks and Valleys
1971–1978

One AFC Central Championship

Blanton Collier retired after the 1970 season, ending a long and distinguished coaching career as coach of the Browns. Assistant Nick Skorich replaced Collier and become the team's third head coach. Skorich joined the Browns as an assistant in 1964 after a three-year head coaching stint with the Eagles and worked his way up from defensive line coach to offensive coordinator during his time with the Browns.

Skorich was a disciplinarian; the exact opposite of the quiet, easygoing Collier. He thought that the Browns were a championship-caliber team and aimed to push them toward a Super Bowl victory by putting in more hours on the practice field: "I intend to practice longer and tougher and it will carry us into the season."

In addition to longer practices, Skorich was relying on Mike Phipps, his young quarterback. Phipps enjoyed an outstanding college career at Perdue University, and became eligible for the college draft prior to the 1970 season. Browns management became so enamored with Phipps that they traded receiver Paul Warfield to the Dolphins for the third overall draft pick, which they used to draft him. Phipps split time with veteran Bill Nelsen in 1970, and the new coach planned to start him in 1971.

The Good, the Bad, and the Ugly

Phipps did not keep the starting job for long as he struggled in the preseason. The Browns only managed five points against the Rams, then 15 against the Cowboys, netting one touchdown in those two games. Skorich realized that Phipps was not ready to start, so he reverted to Nelsen for the opening game against the Oilers.

That game was a roaring success, and the Browns trounced Houston, 31-0, behind the solid running of Leroy Kelly and five interceptions by the defense. Kelly had a pair of one-yard touchdown runs in the first half, and Nelsen added a short touchdown toss to Collins in the third quarter. The game was so out of reach for the Oilers that Mike Phipps played in the fourth quarter and added to the route by throwing an 18-yard touchdown to Frank Pitts late in the game.

The Browns won three of their next four to take a commanding two game lead in the division with a 4-1 record. The latest win was a 27-24 thriller against the Bengals where Bo Scott scooted across the goal line for the winning score with just 39 seconds left in the game. The victory dropped the Bengals to 1-4, and it appeared that the Browns would cruise to their first AFC Central Division Championship.

The feeble Denver Broncos came to Cleveland the following week and completely dominated the Browns, 27-0. The shutout was Cleveland's first during the regular season since their inaugural season, 1950. The Browns then lost their next three in a row, including one game to the Steelers, and found themselves in a tie at 4-5 with Pittsburgh for the divisional lead.

Things turned around for Cleveland the rest of the way as they found their running game and began to put points on the board again. The Browns won their last five regular season games, while the Steelers only managed to go 2-3 in the same stretch. As a bonus, the Browns clinched their first AFC Central crown by beating the Bengals in week 12. Skorich's squad seemed to gain a second wind in the stretch run and started playing its best football of the year just in time for a playoff run, giving credence to his tough practice philosophy.

For the third time, Cleveland hosted the Baltimore Colts in the playoffs, this time in a fog-filled Municipal Stadium. The Browns won the first match up in 1964, 27-0, while Baltimore dominated in 1968, 34-0. Baltimore's tough defense dominated this contest, holding Cleveland's running game to just 69 yards and forcing three Bill Nelsen interceptions. Phipps relieved Nelsen late in the game, but the Browns just managed one field goal and lost, 20-3.

Despite the playoff setback in 1971, Browns fans looked forward to an even better showing in 1972. The Browns infused the aging secondary and offensive line units with young talent. Doug Dieken took Dick Schafrath's spot at right tackle, and Thom Darden, the team's number one pick in the draft, replaced Walt Sumner at strong safety. Mike Phipps got another chance to take over the reigns at quarterback as well.

It took some time for the team to adjust to all of the new faces; Cleveland went 0-6 in the preseason, and then lost the season opener to the Packers, 26-10. The Browns won in week two at Philadelphia, but lost two of their next three. Though Cleveland's 2-3 record was disappointing, Skorich did not panic while his team tried to build chemistry and develop a rhythm.

Skorich made two personnel moves that really sparked the team. Thom Darden moved from strong safety to free safety, and Walt Michaels took over the strong side for Darden. Bob Demarco also took over for Fred Hoaglin at center. These moves, combined with the coach's patience with the rest of the squad, paid off as Cleveland ripped off victory after victory in thrilling fashion.

The streak started in Houston, where Phipps led the Browns on an 80-yard touchdown drive in the fourth quarter, and then snuck over the goal line for the winning score in a 23-17 win. The Browns traveled to Denver next, and Darden intercepted a pass during a Broncos comeback attempt with 1:12 left in the game that protected Cleveland's 27-20 win. The Browns then shut out the Oilers in Cleveland, and then headed to San Diego for a Monday

Night Football contest with the Chargers. Again, Phipps came through in the final moments. Down 17-14 with 51 seconds left, the young quarterback hit Frank Pitts on a 38-yard strike to win the game, 21-17. One week later against the Steelers, Phipps drove the Browns down the field in the closing seconds and set up a game-winning field goal by Don Cockroft in a 26-24 win. A 27-10 victory against the Bills seven days later extended Cleveland's winning streak to six games, and set up a showdown with the Steelers in Pittsburgh for the Central Division lead.

Although the Cleveland and Pittsburgh had been squaring off against each other since 1950, a true rivalry never materialized because the Steelers were perennial losers while the Browns were always fighting for the championship. This was changing quickly, though. The Steelers, coached by former Browns linebacker Chuck Noll, had a young nucleus of stars, and were shedding their losing ways. Nick Skorich's hard-line coaching style improved the Browns as well, although most of Cleveland's core consisted of veterans.

The Browns and Steelers entered the game tied atop the standings at 8-3, but the pre-game hype was more entertaining than the actual game. Don Cockroft's missed field goal in the first quarter was the closest that The Browns came to scoring. After suffering one shut out in their first 22 years, the Browns posted their second goose egg of the season, losing by a score of 30-0. Despite the blowout, the six-game winning streak assured Cleveland of its second straight post-season appearance. The Browns won their final two games, but so did the Steelers, who won the division. The Browns finished the season 10-4, one game behind Pittsburgh, and earned the AFC wildcard berth in the playoffs.

The Browns traveled to Miami to face the undefeated Dolphins in the first round of the playoffs. Miami was the first team to complete a perfect regular season since the 1948 Browns, and they were the first NFL team to do so since the 1942 Chicago Bears. The game got off to a rocky start for Cleveland when Miami blocked a Don Cockroft punt and returned it for a score in the first quarter. Garo Yepremian added a field goal later in the quarter, and the Dolphins led, 10-0, at the half. In the third quarter, Phipps led the Browns on a drive and capped it off himself with a five-yard touchdown run. Phipps led the offense on another drive in the fourth, and connected with wide out Fair Hooker on a 27-yard scoring strike. The 14-13 lead did not last, though, as Miami drove down the field and scored a touchdown. Despite Phipps' heroics, he tossed five interceptions in the game and the Browns lost, 20-14. Miami would go on to complete the first untied, undefeated championship season since the 1948 Browns.

That game was probably Cleveland's best and last chance at a title. The Browns' core of veterans was beginning to show signs of age, and Mike Phipps development into a good NFL quarterback was much slower than expected. Phipps struggled again in 1973, completing less than half of his passes and tossing 20 interceptions. The Browns finished 7-5-2 in 1973, good enough for just third place in the division.

To make matters worse, Leroy Kelly announced his retirement after the season. The Browns entered 1974 without a running threat or a solid quarterback on offense that left fans worrying for the first time since Otto Graham retired. Clevelanders realized their worst fears in 1974 when the Browns suffered through the franchise's second losing season in team history with a 4-10 record. The Browns started out 1-5 and never recovered. Mike Phipps again struggled, and former 13th round selection Brian Sipe saw some action in his relief.

Art Modell fired Skorich after the season, even though many of the team's failures were because of the front office. The Warfield-for-Phipps trade was a disaster; Warfield caught TD after TD for Miami while Phipps struggled with interceptions. The team was old on both sides of the ball, and Cleveland failed to draft suitable replacements for retiring stars. Nevertheless, ownership needed to shake up the organization and try to turn the situation around for the 1975 season.

More Bad, More Ugly

Forrest Gregg replaced Skorich immediately as the new sideline general in Cleveland. Gregg

starred as an offensive lineman with the Green Bay Packer dynasty of the 1960s, and moved into the coaching ranks with the Chargers after his retirement. Gregg was Cleveland's offensive coordinator in 1974, and was a taskmaster cut in the mold of Vince Lombardi, his coach during his playing career.

The new coach had a considerable job in 1975. He needed to find a way to exploit the strengths of Mike Phipps while hiding his weaknesses. He also had to find a new running back and some young defensive talent to make the Browns competitive.

The season started out horribly for Cleveland. The offense failed to score more than 17 points in their first nine games, and lost every one of them. The media began discussing a possible zero-win season for the Browns. The offense finally awoke in the fourth quarter against the Bengals on November 23. Down by a score of 23-15, Cleveland scored 20 points in the last period to win, 35-23. Greg Pruitt, a second-year running back from Oklahoma, became the eighth player in NFL history to gain 100 yards receiving and rushing in the same game.

The Browns split their last four games to finish 3-11. For the second consecutive year, Cleveland posted its worst record in team history. Although Gregg found his running back in Pruitt, he did not succeed with Phipps. The sixth-year quarterback had his worst season as a pro, throwing just four touchdowns against 19 interceptions. The defense was still atrocious and gave up over 30 points five times in 1975.

The Browns continued to add younger players in 1976. Linebacker Gerald Irons and cornerback Ron Bolton came in to bolster the defense, while Jerry Sherk, a second round pick in 1970, surfaced as the defensive leader. Greg Pruitt emerged as the star running back, and Phipps would compete with Brian Sipe for the starting quarterback roll.

Despite the personnel moves, Cleveland limped to a 1-3 start. They beat the Jets in the season opener, but Phipps broke his shoulder in that game. The Browns then proceeded to lose their next three games, each by 17 or more points, while backup quarterback Brian Sipe grew accustomed to starting.

The Browns hosted the defending Super Bowl champion Steelers in week five, and trailed at the half, 10-6. All seemed lost when Brian Sipe went down in the second quarter with a concussion, but third-string quarterback Dave Mays came in and calmly led the team to a go-ahead touchdown. Don Cockroft added his third and fourth field goals of the game to seal the game for Cleveland, who snuck past the Steelers, 18-16.

The win sparked the Browns, and they won seven of their next eight games to climb back into the playoff race. The Browns traveled to Kansas City to face the Chiefs on the last week of the season. A Browns win combined with losses by the Steelers and Bengals would propel Cleveland into the playoffs. Unfortunately, the Browns lost to the Chiefs, 39-14, while committing six turnovers in the game. Pittsburgh beat the hapless Oilers, 21-0, anyway, so a Browns win would not have made a difference.

The Browns slumped in 1977 after a promising 5-2 start. Players started to tire of Forrest Gregg's relentless yelling, long practices, and micro managing. With one week to go in 1977, Modell fired the fourth coach in team history, and replaced him with Dick "Little Mo" Modzelewski. Modzelewski was formerly a defensive lineman for the Browns, and moved to the coaching staff when he retired. Little Mo spent eight years as Cleveland's defensive line coach until 1977, when he picked up the overall defensive coordinator job.

Forrest Gregg went on to coach the Bengals and Packers in the NFL, and then did a stint at Southern Methodist University, his alma mater. His greatest success as an NFL coach came in 1981 when he led the Bengals to the Super Bowl, which they lost, 26-21.

Change of Pace

The last game for the Browns in 1977 was in Seattle against the Seahawks. The Browns opened a 13-point lead in the first half, and led late in the fourth, 19-13. Seattle then drove 80 yards down the field in just three plays to score the winning touchdown and steal the game from

Cleveland, 20-19. The loss dropped the Browns to 6-8, their third losing season in four years.

Modzelewski knew that Modell hired the head coaches from within the organization, so Little Mo felt he was in line for the permanent post. On December 28, 1977, however, Modell named Sam Rutigliano the new coach for the Browns, citing the need for a change in philosophy to turn the club's fortunes, and going outside of the organization for the first time in history. Modzelewski, upset about the hire, resigned from the team in protest.

The previous two Cleveland coaches were strict, Paul Brown-type disciplinarians, but Rutigliano took a completely different approach with his players. Sam was a soft-spoken, Blanton Collier-like teacher who believed in motivating players through instruction and keeping his players at an even emotional level. Rutigliano was an offensive-minded coach, and Modell hoped that the new coach could develop Brian Sipe into a solid NFL quarterback, just as he did with Jim Plunkett of the New England Patriots.

In order to turn the team around, the Browns also needed good players. Since Brian Sipe was Rutigliano's quarterback, the Browns traded Mike Phipps to the Bears for their first round draft pick, the 20th selection overall. The Browns then traded that pick to the Rams for their first (23rd overall) and fourth round selections. The Browns used that pick to draft Alabama wide receiver Ozzie Newsome. The Browns also had their own draft pick (12th overall) to work with in 1978, and they used that selection to bolster the defense, choosing linebacker Clay Matthews from USC.

Cleveland got off to a fast start, beating San Francisco, 24-7, in the home opener. Legendary running back O.J. Simpson, the first back to gain over 2,000 yards rushing in one season (1973), started his first game as a 49er. Ozzie Newsome, who moved to tight end, scored his first touchdown on a 23-yard running play.

The Browns stayed at home for a game against Cincinnati, where the teams battled to a 10-10 tie late in the fourth. Bengals kicker Chris Bahr had an opportunity to win the game on the last play, but missed the 37-yard try. The game went to overtime, where Don Cockroft connected on a try from 27 yards to give the Browns a 13-10 win and a 2-0 start to the season. After easily beating the Falcons, Cleveland traveled to Three Rivers Stadium in Pittsburgh to face the Steelers. This particular stadium gave the Browns nothing but problems. The Steelers started playing home games there in 1970, and beat the Browns all eight times the teams faced off there. The teams entered the game tied for the Central Division lead, just as they did in 1972. Unlike the 1972 game, which ended in a 30-0 romp, the Browns were able to keep this contest competitive.

Regulation ended in a 9-9 tie, marking Cleveland's second overtime game in three weeks. Pittsburgh took the opening kickoff and drove 42 yards in eight plays. On the ninth play of the drive, the Steelers uncharacteristically called a trick play in where quarterback Terry Bradshaw handed off to running back Rocky Bleier, who then handed off to wide receiver Lynn Swann. Instead of running or throwing the ball, though, Swann pitched it back to Bradshaw, who then tossed it to tight end Bennie Cunningham for an easy touchdown and a win.

That loss crushed the Browns and halted all of the momentum that they had. Cleveland lost five of the next seven after the Pittsburgh game, beating the amateurish Bills and Saints in the stretch. By the time that the Browns rebounded with a 45-24 shellacking of the Colts, they were 6-6 and out of contention for a playoff spot. However, the team showed character by splitting its last four games to avoid another losing season and finishing 8-8.

Thanks to Rutigliano, the Browns had the fifth best offense in the league in 1978, and the defense made huge strides. Brian Sipe developed into one of the best quarterbacks in the league, and the young rookies acquired in the draft showed signs of brilliance. The team also seemed to perform best under pressure and had a flair for dramatic, heart-pounding finishes. The wild ride was just beginning.

In 1971, the Browns hired Nick Skorich (center) as head coach following Blanton Collier's retirement. He previously served as a defensive assistant with the Browns since joining the team in 1964, and became the third head coach in Browns history. Skorich, who coached the Philadelphia Eagles from 1961 through 1963, remains the only headman in Browns history to have prior NFL head coaching experience. (Courtesy of the Cleveland Press Collection, Paul Tepley.)

Mike Phipps (#15) heads off the field surrounded by excited Browns fans after he leads the Browns to a 35-23 win over the Bengals. The Browns traded All Pro receiver Paul Warfield to the Dolphins before the 1970 season in exchange for the draft pick used to select Phipps. The trade was one of the worst in Browns history; Phipps never developed the pocket presence or accuracy of an NFL quarterback. Warfield, meanwhile, was an instrumental part of Miami's 1972 perfect season and played in three Super Bowls with the Dolphins. (Courtesy of the Cleveland Press Collection, Paul Tepley.)

Milt Morin was the best tight end in the history of the Cleveland Browns . . . until Ozzie Newsome came along in 1978. Morin caught 271 passes for the Browns and appeared in three Pro Bowls during his 10-year career, but almost never played with the Browns because when Cleveland drafted him in 1966, so did the Chargers of the AFL. Morin wavered, but ended up choosing cold Cleveland over sunny San Diego because of Cleveland's rich football history. (Courtesy of the Cleveland Press Collection, Paul Tepley.)

Abe Abraham (center), or "The Man in the Brown Suit" as Browns' fans knew him, was in charge of retrieving extra point and field goal tries for the Browns. Abe, getting measured for a new suit in the photo, was a crowd favorite at Cleveland Municipal Stadium. In 1964, Abe did not show up for a game against the St. Louis Cardinals. When he finally arrived later in the game, he received a standing ovation. As for the reason for his tardiness, Abe later explained that he could not find those famous brown pants! (Cleveland Press Collection, Paul Toppelstein)

Joe "Turkey" Jones, intercepting a Kenny Anderson pass here, earned his nickname thanks to a prank his teammates pulled on him during his rookie season. Before Thanksgiving in 1970, veterans on the team sent Jones and the other rookies off to distant farms so they could get "free turkeys" which did not really exist. Jones continued his futile search for hours after the other rookies came back. In 1971, the veterans again pulled the prank, and Jones fell for it again! Turkey is more famous for his sack of Terry Bradshaw in 1976 that kick-started the Browns-Steelers rivalry. Early in the fourth quarter with the Browns down, 10-6, Jones whipped around the left end, picked up Steelers quarterback Terry Bradshaw, and dumped him on his own head. Flags flew, and Bradshaw left the game with a concussion. The Browns rallied to win on the strength of Dave Mays' arm (*see next page*), and Turkey became so hated in Pittsburgh that he had to ride a separate bus and sleep in a different hotel when the Browns traveled to Pittsburgh. (Courtesy of the Cleveland Press Collection, Paul Tepley.)

Dave Mays was Cleveland's third-string quarterback in the late 1970s, but earned his spot in Browns history with one amazing comeback. In the same game that saw Turkey Jones bounce Terry Bradshaw onto the ground, the Browns were trailing in the fourth quarter, 10-6. Starting quarterback Brian Sipe left the game in the second quarter with a concussion, while backup Mike Phipps was injured with a separated shoulder. Mays engineered a touchdown drive in the third quarter on the strength of a halfback option pass he called in the huddle. The drive ended with a one-yard scoring run that gave them a 12-10 lead. In the fourth quarter, Mays guided the Browns down the field twice more, with both drives ending in field goals. The Browns won the game, 18-12. Mays stayed in the NFL for two more years, and began a dentistry practice after football. Sadly, a jury convicted him of welfare fraud after his career was over, and sentenced him to 5-15 years in prison. (Courtesy of the Cleveland Press Collection, Paul Tepley.)

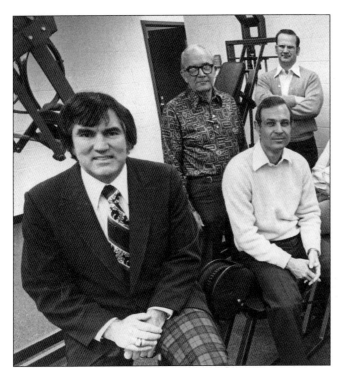

Forrest Gregg (left) became the fourth head coach in Browns history in 1975, but only lasted three years in the job. Gregg led the Browns to records of 9-5 in 1976 and 6-7 1977, but was fired because he did not get along with the Browns' front office personnel. Executive vice president Peter Hadhazy wanted to trade struggling quarterback Mike Phipps, but Gregg refused to allow the trade of one of his favorite players. Gregg reportedly argued with Art Modell's wife, Pat, exasperating the situation that ultimately led to his dismissal. (Courtesy of the Cleveland Press Collection, Tony Tomsic.)

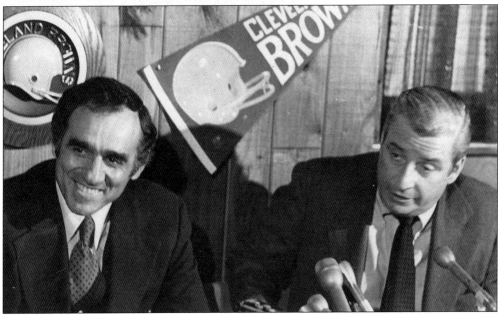

The Browns named Dick "Little Mo" Modzelewski the interim coach for Cleveland's final contest in 1977 after Gregg's termination. Little Mo, knowing that Art Modell always promoted from within, felt he was in line to be the team's next coach, but for the first time in team history, Modell hired a coach from outside the team. Sam Rutigliano (left) accepted the position on December 27, 1977. Rutigliano agreed with management that Brian Sipe would become the starter, and the Browns traded Mike Phipps to the Bears later in the off-season. (Courtesy of the Cleveland Press Collection, Frank Reed.)

The taxi squad, or practice squad in the modern NFL, is another Paul Brown innovation. Back in the 1940s, Brown hired young prospects to work as taxi drivers in Mickey McBride's cab company during the season. Then, if Brown needed a player to fill the roster, he would sign the player to a contract. This practice kept the players in Cleveland and prevented them from signing with other teams. Eventually, every NFL club adopted the practice, although players no longer drive cabs. Brian Sipe was one player who took advantage of the squad by eventually parlaying it into a successful NFL career. Sipe, selected in the 13th round of the 1972 draft, spent his first two years on the taxi squad. He ultimately made the team and supplanted Mike Phipps as the starting quarterback. (Courtesy of the Cleveland Press Collection, Paul Tepley.)

The 1970 Paul Warfield-for-Mike Phipps trade with the Dolphins was one of the worst in team history, but the Browns corrected their error in 1976 by bringing Warfield home as a free agent. After playing in Miami for five seasons, Warfield bolted to the World Football League in 1974 and spent two seasons there. When the WFL folded after the 1975 season, Warfield was free to sign with any team, and he returned home. His last game at Municipal Stadium was on December 11, 1977, in a battle against the Houston Oilers. Paul caught two passes for 24 yards in the contest, and left the field to a standing ovation. He was later inducted into the Pro Football Hall of Fame as part of the class of 1983. (Courtesy of the Cleveland Press Collection, Paul Tepley.)

Six

The Kardiac Kids

1979–1984

One AFC Central Championship

From 1946 through 1973, the Cleveland Browns never had a losing season. In those first 28 years, the team won seven championships, and saw postseason action 20 times. In the eight years since then, the Browns failed to produce a winning mark six times and did not play in a single playoff game. Unproductive drafts, poor trades, and intolerable coaches were all factors in Cleveland's sudden stretch of losing football.

The Browns pinned hopes for a turnaround on head coach Sam Rutigliano and his philosophical approach. The confident yet understated coach thought that the Browns were among the elite teams in the league, and would return to their winning ways in 1979. "We've got to be encouraged about a lot of things, especially our offense," said Rutigliano.

Much of Rutigliano's confidence stemmed from the faith he had in his gun slinging quarterback, Brian Sipe. After an erratic start to his career, Sipe blossomed under Rutigliano's guidance, becoming one of the best quarterbacks in the NFL. He shared his coach's optimism on Cleveland's 1979 prospects: "There is no doubt in my mind that we will have a high-scoring machine this year. We have all of the tools, and . . . a sense of direction. I'm excited about it."

Kardiac Arrest: Heart Stopping Games

Sipe had good reason for his excitement. Cody Risen, a seventh round draft pick, rose from third on the depth chart to starting left guard, shoring up the offensive line. The Browns instantly improved their 27th-ranked defense when they traded two draft picks for end Lyle Alzado. Denver was forced to trade the AFC Defensive Player of the Year after he walked out of the Broncos' training camp due to a contract dispute.

The Browns started the season with three thrilling victories. First, they beat the Jets in overtime, 25-22. The key was a three-play, 66-yard drive by the offense with 30 seconds left that set up a tying field goal. The next week in Kansas City, the Browns opened a 20-0 lead in the third quarter, but fell behind 24-20 in the fourth. The offense again ripped off a last-minute drive to score the go-ahead touchdown and win, 27-24. In week three, the Browns took a 13-10 lead against the Colts on a Don Cockroft field goal with 1:51 remaining. Baltimore's comeback attempt fell short when they missed a tying field goal attempt as time expired.

Cleveland fans finally got a rest in the fourth week as the Browns nailed the Cowboys, 26-7, on Monday Night Football. The defense played their best game of the season, forcing five turnovers, sacking Roger Staubach four times, and scoring a touchdown. Cleveland paid the price for the victory, though. Lyle Alzado went down in the game with a knee injury that slowed him down for the rest of the year.

The Browns lost their next two games and gave up a total of 82 points without Alzado, but he returned in week seven. The defense held the Redskins to just two field goals through the first 58 minutes, but the offense only managed three of their own. The Redskins scored the winning touchdown with less than a minute left to win, 13-9. Despite a spectacular start, the Browns were 4-3, one game behind Houston and Pittsburgh in the AFC Central.

The Bengals were next up on the schedule. Cincinnati entered the game 1-6, but always played well against the Browns. This day was no different, as Cleveland needed a rally in the fourth to pull out the game. Two more wins, an 18-point victory over the Rams and a five-point squeaker against the Eagles, drove Cleveland's record to 7-3. The Browns were one game behind the Steelers but led the wild card race.

Sometime in the middle of the 1979 season, a banner cheering on the Browns appeared atop the courthouse in Cleveland. The banner referred to the team as the "Kardiac Kids," which was a perfect description of this team. Five of Cleveland's seven wins came as the result of fourth quarter rallies while one of the losses was decided in the closing moments. Local sportswriters began using the nickname in their coverage, and fans took to it immediately. Eventually, the entire NFL knew the Browns as the Kardiac Kids.

The club lived up to its new nickname in the remaining six games as each contest was decided in the fourth quarter. A comeback attempt fell short against the Seahawks in a 29-24 loss, and then the Browns beat the Dolphins in overtime after tying the game in the final two minutes. The Kardiac Kids lost another heartbreaker in Pittsburgh when the Steelers tied the game at the end of regulation and beat the Browns in overtime—Cleveland's third overtime game of the year. The Three Rivers Jinx lived on: Jinx 10, Browns 0.

The Browns kept their playoff hopes alive with a 14-7 win against the Oilers, and despite a failed comeback attempt against the Raiders, they were still eligible going into the last week of the season. The game, the season, and the first Browns playoff game in eight years came down to the final play. Sipe led the team down the field on another last-minute drive, and on the last play of the game attempted a pass into the end zone. The throw flew just out of reach of Reggie Rucker's outstretched arms and brushed his fingertips, but fell incomplete, killing Cleveland's playoff dreams.

Despite missing the playoffs, 1979 was the most exciting year in more than a decade for the club. Twelve of 16 games were decided on the last possession, including the last seven. The Browns finished the season with a 9-7 record with their best defensive player, Lyle Alzado, rendered ineffective due to his ailing knee.

Alzado returned in 1980 with a clean bill of health, and the Browns hired Marty

Schottenheimer as the new defensive coordinator to improve Cleveland's 22nd-ranked defense. Schottenheimer, who previously served as the linebackers coach in Detroit, planned to use the 3-4 defense in 1980, which uses three defensive lineman and four linebackers. This fit nicely with Cleveland's personnel because the Browns had a flock of talented linebackers while the defensive line corps was thin.

The return of Alzado, the addition of Schottenheimer, and the drafting of Heisman Trophy winning tail back Charles White had fans and local media predicting a Cleveland Super Bowl run for the 1980 season. Brian Sipe had his best season in 1979, throwing a league-high 28 touchdowns and amassing almost 3,800 yards through the air, although he also tossed 26 interceptions. The hometown was so enamored over the quarterback that they coined a new term to describe their expectations; they called 1980 the year of the "Siper" Bowl.

The Siper Bowl run of 1980 got off to a slow start as back-to-back losses against the Patriots and Oilers had experts scratching their heads. Rookie Charles White only gained a combined 18 yards through the first two games, and the flare of the Kardiac Kids seemed to be missing. The offense failed to move the ball, and the referees penalized the defense, especially Lyle Alzado, at the most crucial times.

The offense finally found its rhythm against the Chiefs in week three. Charles White had a breakout game, gaining over 150 combined yards, and Sipe set a team record by completing 13 consecutive passes. Cleveland beat the Chiefs for the second straight year, 20-13, in typical Kardiac Kid fashion, scoring the winning points in the fourth quarter.

The Kardiac Kids were back, and provided ulcer-causing excitement for the rest of the season. After holding off Tampa Bay's furious comeback attempt for a seven-point win, the Browns lost a close one to Denver, 19-13. Even though the Browns' record stood at 2-3, the team remained confident that things would start to click.

Click they did. Schottenheimer's defense finally showed up against Seattle in a 27-3 rout of the Seahawks. Facing a third-and-twenty against the Packers, Sipe miraculously found receiver Dave Logan for a 46-yard touchdown with 16 seconds to go. The Steelers came to Cleveland next and built three separate 10-point leads before finally succumbing to the Kardiac Kids in the fourth quarter. Riding a three-game winning streak, the Browns staved off two comebacks by recovering onside kicks in consecutive weeks—first against the Bears, then against the Colts.

The Kardiac Kids were on a five-game winning streak as they rode the team bus to Pittsburgh, but fans and media were nervous about this contest. The Steelers were two-time defending NFL champions, and unlike in their last game against the Browns, Terry Bradshaw and Lynn Swan would start. Then, of course, there was the Three Rivers Jinx, now in its 11th year. Coach Rutigliano did not buy into jinxes, though: "Our players realize that Three Rivers is a myth . . . The problem wasn't The Jinx, the problem was [the Steelers] were very good."

The Browns and Steelers toiled at Three Rivers Stadium in one of the greatest games of the entire rivalry. Pittsburgh dominated early in the seesaw battle, but two key interceptions by Clinton Burrell and two sustained drives by the Kardiac Kids helped the Browns to lead at halftime, 13-7. Cleveland maintained that lead through most of the second half, and almost had the game locked up. The Browns faced a forth down deep inside their own territory with 2:00 remaining in the game when punter Johnny Evans intentionally took a safety to make the score 13-9. The Steelers took possession after the free kick, and with 11 seconds left in the game, Bradshaw found Swann in the end zone to win the game.

In spite of Rutigliano's beliefs, The Jinx seemed to be in full effect. Browns kicker Don Cockroft missed a field goal in the first quarter, and placekick holder Paul McDonald fumbled the snap on an extra point attempt in the second. If either of those kick attempts were successful, Bradshaw's touchdown would not have mattered.

The Cleveland Browns of previous years might have carried the memory from that loss with them throughout the rest of the season, but the Kardiac Kids were different. They responded the next week by pounding the Bengals, coached by former Browns headman Forrest Gregg, to the tune of 31-7. Cleveland improved its record to 8-4 with the win, and Houston lost to the

Jets, dropping them to the same 8-4 record.

As luck would have it, Cleveland played the Oilers in the Astrodome the next week. The Browns jumped out to a quick 7-0 lead barely one minute into the game after Houston fumbled the opening kickoff. Cleveland extended the lead to 14-0, and later pushed it to 17-7. Two ex-Raiders, quarterback Kenny Stabler and tight end Dave Casper, hooked up for a 30-yard Oilers touchdown in the fourth quarter to cut Cleveland's lead to three. Sipe and the offense stalled, and Houston took over looking to tie or take the lead late in the game. Browns safety Thom Darden came to the rescue by forcing Casper to fumble. Again, the offense could not move the ball, so Houston got the ball back once more. The Oilers drove down the field and approached field-goal range when Clarence Scott, Cleveland's other starting safety, stepped in front of a Stabler throw at the Browns' 24-yard line to preserve the lead and win the game. For once, the defense made the big plays instead of the offense. More importantly, the Browns overtook sole possession of the AFC Central.

A typical Browns victory against the Jets followed as Sipe led a fourth quarter scoring drive to pull out a three-point win. There was more of the same against the Vikings the next week, but this time the Vikings were on the winning side. Tommy Kramer hit Ahmad Rashad with a "Hail Mary" touchdown pass that temporarily derailed Cleveland's bid for the division championship. The Browns took the crown, though, by beating the Bengals on a last-minute Cockroft field goal in the season finale.

For the first time in almost a decade, the Browns were a post-season team! Not only were the Browns going to the playoffs, Cleveland would host a playoff game against the wild card team. Topping it off, the Browns held the home-field advantage throughout the playoffs because they had the best record (11-5) in the AFC.

The Oakland Raiders demolished the Houston Oilers in the wildcard round to earn a ticket to Cleveland. Even though the Raiders sported an 11-5 record of their own, most experts had the Browns winning the game easily. Cleveland just completed its best season since 1965, Brian Sipe won the NFL MVP award, and Sam Rutigliano was the UPI Coach of the Year. The Browns had an unstoppable running game, an unstoppable passing game, and a defense good enough to win the championship.

On game day, the field-level temperature was one degree at kickoff and negative 37 degrees with the wind chill. Both offenses sputtered as the teams battled through a scoreless first quarter. In the second period, the wind knocked down a Jim Plunkett pass, enabling Browns safety Ron Bolton to intercept it, and then raced 42 yards for a touchdown. Oakland blocked Cockroft's extra point attempt, then drove 62 yards down the field for a score late in the half. Cleveland took the lead in the third with two Cockroft field goals, and the Raiders answered in the fourth on another sustained drive that ended in a touchdown giving Oakland a 14-12 lead.

Late in the fourth, the Raiders faced a fourth-and-one at Cleveland's 15-yard line, but they really needed about two feet to pick up the first. Oakland coach Tom Flores sent in a play for the offense instead of trying a 37-yard field goal because three points did not seal the game. Plunkett took the snap, and handed the ball to Mark van Eeghan, who had scored both Raider touchdowns earlier in the game. Van Eeghan barreled over the left side of the line, and a huge pile formed. Better than 78,000 Browns fans roared when a measurement revealed that van Eeghan came up about six inches short. Cleveland's defense held the Raiders to give the ball back to Sipe and the offense for one final shot at the win.

The Browns started out at their own 15-yard line with a stiff wind in their face and the clock showing 2:22. On the first play of the drive, Sipe's pass fell incomplete, adding to the tension. Sipe dropped back to pass on the second play and directed his toss toward Ozzie Newsome. Newsome stopped his pattern and waited for the under-thrown ball, causing his defender to slip and fall. This enabled Newsome to run another seven yards with the ball, and at the two minute warning, Cleveland had a first-and-ten at their own 44-yard line.

After the break, Sipe under threw another pass, then slipped on some ice on the ensuing play

76

to bring up a third-and-long situation. The third down pass also fell incomplete, but the Raiders were penalized for illegal contact, giving the Kardiac Kids a second life. Sipe hit Greg Pruitt on the sideline with his next pass, and the back scampered out of bounds at the Oakland 28 yard line. Two plays later, the Browns caught the Raiders off-guard with a draw play, which Pruitt took down to Oakland's 14-yard line. Another run gained just one yard, and the Browns faced a second-and-nine with 0:46 left on the clock.

Sipe called a timeout to talk it over with his coach on the sidelines. Though everyone in the stadium expected a run, a timeout, then a field goal try to win the game, Rutigliano was not confident in Cockroft, especially at the open end of Municipal Stadium in high winds. Rutigliano called for a pass play, Red Right 88, to end the game right there. The 1980 league MVP dropped back, read the field, and tossed a ball towards Newsome in the end zone. The wind slowed it down, though, and Raider defender Mike Davis stepped in front of it for an easy interception. The Browns, unable to stop the clock, were dead with 41 seconds left in the game. The Kardiac Kids finally had a coronary and their "Siper Bowl" dreams went unfulfilled for yet another year. Sam Rutigliano took a lot of heat for the play call after the game since the pass bucked conventional wisdom and failed miserably. Rutigliano defended the call, citing that Cockroft's knee was bothering him and that the high winds, slippery field conditions, and bitter cold made the kick a risky call, too.

Rutigliano was confident that the Browns would build on that exciting season, despite the heartbreaking loss in the playoffs. Heading into the 1981 season, Returning starters Sipe, Pruitt, Alzado, Newsome, and White were the nucleus of a veteran team that now had playoff experience. "Siper Bowl" fever still ran high in Cleveland, and the fans expected the Kardiac Kids to pick up where they left off.

The Phantom Dynasty

Unfortunately for Cleveland, that is exactly what happened. The Chargers and their powerful offense ran over the Browns defense in a 44-14 Cleveland loss. The Oilers came into Municipal Stadium the next week and shut down the offense for a 9-3 Houston win. The Browns battled back to improve their record to 4-4, but lost seven of their last eight games and finished with a 5-11 record.

Brian Sipe regressed to pre-1978 form, throwing 25 interceptions. Although the offense was third best in the league, the running game disappeared. The defense improved under Schottenheimer, but they were still an average unit at best. Worst of all, the Browns seemed to fall apart in crucial situations instead of taking control of the game. The Kardiac Kids were a distant memory.

The Browns improved their defense for 1982 with two key acquisitions. First, Cleveland traded three high draft picks to the Buffalo Bills for the rights to Tom Cousineau. Cousineau, a Cleveland native, was the first overall pick in 1979, but refused to play in Buffalo and fled to the Canadian Football League, where he spent three seasons. The Browns also picked up linebacker Chip Banks from USC with its first pick in the 1982 draft. These two players, along with veterans Clay Matthews and Dick Ambrose, gave the Browns one of the best linebacking units in the league.

Cleveland opened the season in Seattle, and walloped the Seahawks, 21-7. Marty Schottenheimer's defensive scheme was the key to victory; he used rookie Chip Banks both as a down lineman and as a linebacker, thoroughly confusing Seattle's line. Banks accumulated three of Cleveland's eight sacks in the win.

The Browns then lost a seesaw battle at home against the Eagles, but more importantly, Cleveland, like every other NFL city, lost its football team for 57 days due to a player strike. When games finally resumed in late November, the NFL expanded the playoffs to eight teams per conference, rendering its six divisions pointless in 1982. The owners hoped that the expanded playoff format would entice angry fans to return to the stadiums for the remainder of the year. The league also shortened the regular season to nine games, meaning that each team

had just seven remaining.

After winning their first game back, the Browns lost three in a row, and did not score more than 14 points in any of the three. Rutigliano benched Sipe in favor of the young, left-handed Paul McDonald. McDonald, in his third season, mostly saw duty only as the holder on place kicks, and hoped to propel the Browns into the playoffs with just three games remaining.

Two of those last three were against the Steelers. In the first game, Hanford Dixon, a second-year cornerback, intercepted three passes, recorded a sack and a forced fumble in Cleveland's 10-9 win versus the Steelers. The Browns then went to the Astrodome and beat the Oilers, 20-14, and then lost the season finale to the Steelers in Pittsburgh, 31-27, to finish the season with a 4-5 record.

Even though the Browns had a losing record, they qualified for the playoffs due to the expanded format. Because of their record, though, they drew the top-seeded Raiders in the first round. Unlike the 1980 playoffs, the wildcard did not pull off the upset. The Raiders hammered the Browns, 27-10, by racking up 510 total yards in offense.

Opinions differed on McDonald's 1982 performance. His stats were similar to those of Mike Phipps, as he threw more interceptions than touchdowns and completed less than half of his passes. However, he led the team to two wins in three games—all played with injuries to Mike Pruitt and three starting offensive linemen.

Sam Rutigliano remained unconvinced about McDonald, and held a quarterback competition to determine the starter. Sipe performed better in the 1983 preseason to win the job, and guided the Browns to four Kardiac-like wins. Sipe regained his 1980 form, and the running game came alive. However, Cleveland's record stood at 5-5 after 10 games due to the large number of turnovers committed by the offense.

Schottenheimer's defense completely dominated the next three weeks. For the first time since 1951, the Browns recorded back-to-back shutouts, blanking the Buccaneers, 20-0, and the Patriots, 30-0, in consecutive weeks to push Cleveland's record to 7-5. An 18-point blowout of the Colts all but clinched a playoff spot for the Browns, and they would just need to win one of their next two games to seal the berth.

The first of those two games was against the Denver Broncos and rookie quarterback John Elway. Elway had his best game of the year against the Browns, and Sipe had one of his worst. The rookie threw for almost 300 yards, while the veteran threw three interceptions, and Denver won, 27-6.

Up next were the Oilers, and Cleveland could still clinch a playoff appearance with a win. The Browns went down almost immediately, and trailed Houston, 24-6, at one point in the first half. Mike Pruitt's first fumble of the season set up one of the Houston scores, but the veteran running back scored the next three touchdowns that gave the Browns the lead, 27-24. A Sipe interception set up Houston's tying field goal, and Pruitt's third fumble of the game set up their winning touchdown.

The Browns blew two games in two weeks, and entered the final week of the season now needing a win plus help from Atlanta and New England to make the playoffs. Brian Sipe had his best performance ever against the Steelers, throwing four touchdowns and no interceptions as the Browns glided by the Steelers, 30-17. The Falcons came through as well, downing the Bills, 31-14. The Patriots, however, lost to Seattle, and Cleveland narrowly missed the playoffs. Brian Sipe's finest performance against the Steelers was his last game as a Cleveland Brown. After the season, he signed a contract to play for Donald Trump and the New Jersey Generals of the United States Football League (USFL). Paul McDonald proved in 1984 that he was more like Phipps than Sipe, and the Browns started 1-7. Modell fired Rutigliano and named Marty Schottenheimer the interim coach. Schottenheimer won the job for good by finishing the year with a 4-4 record.

The Kardiac Kids played on the edge, but in the end, they often fell off it. Experts, analysts, and writers all agreed that the Browns would return to greatness, but that dynasty could never get started. Rutigliano's reign, and Brian Sipe's career, ended with just two playoff appearances.

Lyle Alzado was the NFL's Defensive Player of the Year in 1978 for the Denver Broncos, but he walked out of Denver's training camp in 1979, forcing the Broncos to seek a trade. The Browns traded second and fifth round draft selections for Alzado, and he instantly became the defense's leader and a fan favorite. (Courtesy of the Cleveland Press Collection, Paul Tepley.)

Clarence Scott (#22) defends a pass intended for Oilers tight end Mike Barber in the fourth quarter of a game played at snowy Municipal Stadium in 1979. The Browns took a 14-7 lead early in the fourth quarter when Brian Sipe engineered an 87-yard drive that resulted in Mike Pruitt's go-ahead touchdown. The Browns' defense staved off a late Houston comeback attempt to secure the win, but lost their last two games and barely missed the playoffs in 1979. (Courtesy of the Cleveland Press Collection, Paul Tepley.)

Doug Dieken followed Dick Schafrath and Lou Groza in Cleveland's great lineage of starting left tackles. Dieken, the Browns' sixth-round draft choice in 1971, took over for Schafrath during his rookie season and held his post on the line until he retired after the 1984 season, and started a Browns' record 203 consecutive games on the line in his 14 years. When Paul Farren took over Diek's spot in 1985, he became just the fourth regular left tackle in Cleveland's 40-year history. (Courtesy of the Cleveland Press Collection.)

Brian Sipe had one of his best seasons in 1979. Sipe set five individual team passing records for the Browns, racking up 3,793 yards and 28 touchdowns while leading the Browns to their best record since 1976. Along with his outstanding statistical performance, Sipe led seven game winning drives in the fourth quarter or overtime. (Courtesy of the Cleveland Press Collection.)

Lyle Alzado hugs Coach Sam Rutigliano after the Browns miraculously beat the Steelers, 28-27, in Cleveland Municipal Stadium. Down by 12 points in the third quarter, the Browns blew three opportunities deep inside Pittsburgh's territory, but the defense held the Steelers back, forcing three punts. Brian Sipe and the Kardiac Kids caught fire in the fourth, scoring two touchdowns to give the Browns a 28-27 lead with 5:38 left in the game. Steelers quarterback Cliff Stoudt, subbing for the injured Terry Bradshaw, threw an interception to Ron Bolton on the ensuing drive, handing the ball back to the Browns. Cleveland's offense was forced to punt in the final minute, giving the Steelers one last shot at the victory. On the drive's first play, Stoudt threw an interception which would have ended the game, but the play was ruled a sack; Alzado grabbed Stoudt as he threw the ball, and the referee ruled that the quarterback was *in the grasp*. The Steelers completed a 34-yard pass as time ran out, but they were far short of field goal range, and the Browns came out victorious. (Courtesy of the Cleveland Press Collection, Timothy Culek.)

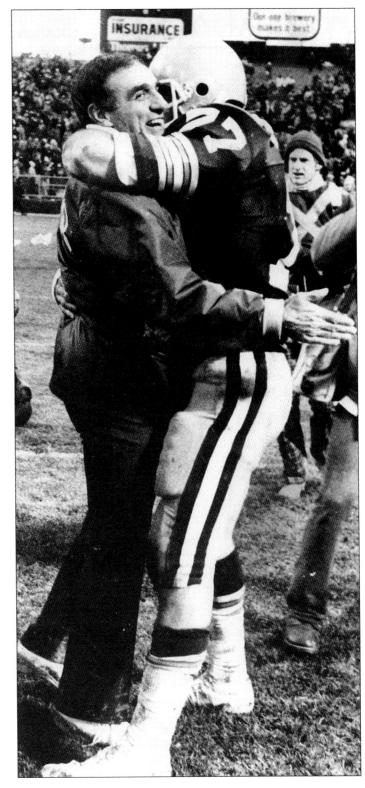

Welcome home! Thousands of excited Browns fans meet the team at Cleveland Hopkins International Airport as the team returns from a successful road trip where they beat Houston, 17-14. The game was not a typical Kardiac Kids win as the Browns opened a 14-point lead in

the second quarter and hung on to win by three. The win improved the Browns' record to 9-4 on the season, giving them a one-game lead on the Oilers (8-4). (Courtesy of the Cleveland Press Collection, Paul Tepley.)

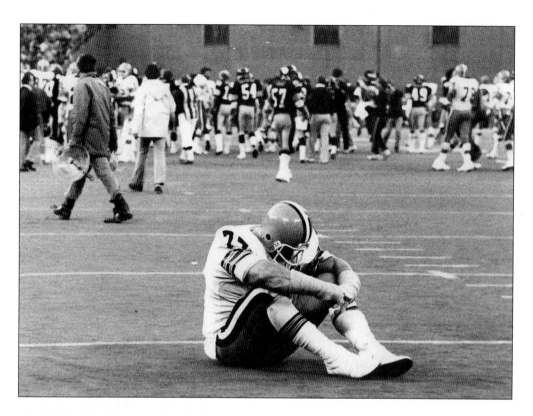

Three weeks after a thrilling win against the Steelers in Cleveland, the Browns lost their 11th consecutive game in Three Rivers Stadium to the Steelers. This contest was especially heartbreaking as Terry Bradshaw led Pittsburgh down the field and threw the winning touchdown pass with 11 seconds left. Lyle Alzado dejectedly sits on the field's artificial turf after the touchdown. (Courtesy of the Cleveland Press Collection, Paul Tepley.)

Brian Sipe (right) watches the defense in a muddy game at Cleveland Municipal Stadium. The scrappy Sipe was the NFL's Most Valuable Player in 1980, breaking his own team records for touchdowns (30), yards (4132), attempts (554), and completions (337). His 91.4 quarterback rating led the NFL. Sipe's MVP award was the 12th in team history; previous winners include Otto Graham (5 times), Jim Brown (4), Lou Groza (1) and Leroy Kelly (1). (Courtesy of the Cleveland Press Collection.)

The Browns won their first AFC Central Division title since 1971. Coach Sam Rutigliano mulls over this banner, placed at the Browns' practice facility by loyal fans. The Browns not only won their division in 1980, but finished with the best record in the AFC, giving them home field advantage throughout the playoffs, a bye week, and the luxury of playing the wildcard game winner in their first playoff game. The Oakland Raiders beat the Oilers, 27-7, in the wildcard round, and traveled to frozen Cleveland to face the Browns on January 4, 1981. (Courtesy of the Cleveland Press Collection, Paul Tepley.)

The Browns and Raiders played a tight game that left Cleveland behind, 14-12, and on Oakland's 14-yard line with 46 seconds left. Cleveland was driving toward the open end of the stadium, so Sam Rutigliano called for a pass play instead of opting for a kick. He told Sipe to "throw it into Lake Erie" if the play was not wide open. Sipe, who was rushed hard on the play, threw a wobbly pass into the corner of the end zone for Ozzie Newsome. Raiders' defender Mike Davis intercepted it to steal the victory. (Cortesy of the Cleveland Press Collection, Larry Nighswander.)

The ill-fated pass play, Red Right 88, became known as "The Mistake on the Lake." The Raiders went on to win the championship, becoming the first wildcard team to win the Super Bowl. The Kardiac Kids did not get back to the playoffs until 1982, when they became the first team in history to make the playoffs with a losing record. Cleveland finished 4-5 that year, and only advanced because the league expanded the playoffs to 16 teams (from 10). The Browns lost their first 1982 playoff game—again to the Raiders. (Courtesy of the Cleveland Press Collection, Paul Tepley.)

SEVEN

Marty Ball and the Hometown Hero 1985–1988

Four AFC Central Championships

Over the past twenty years, the Cleveland Browns franchise transitioned from one of great prominence to a perennial also-ran. Although teams like the 1980 Kardiac Kids provided moments of excitement to win-starved fans, they were never able to hold on to their short-lived glory. The Browns, once a great team going through a down period, became a down team remembering its great past.

The frantic offense and porous defense of the Kardiac days made for great television, but provided fans with more anguish than rapture. Recent championship teams shared a common thread; they all had great defenses. That, and an impressive 4-4 finish during 1984, was the reason Art Modell retained Marty Schottenheimer as head coach. In just four years, Marty transformed the team's defense from one of the worst in the league to one of the best.

One Trade, Three Yards, and a Cloud of Dust

Cleveland's first priority was to find a quarterback to lead the team for the next generation. Art Modell desperately wanted to draft Miami (FL) University's Bernie Kosar. Kosar, a Youngstown, Ohio native, grew up rooting for Cleveland and hoped to one day play for the Browns. However, the young prodigy was projected to go way before the Browns' first pick in the 1985 draft.

So Cleveland's front office got creative. Kosar still had college eligibility remaining, and he did not declare for the draft until after the cutoff date for underclassmen, making him eligible for the supplemental draft later in the summer. The Buffalo Bills held the first pick in that supplemental draft, but they were not interested in Kosar since they drafted Jim Kelly in 1983. The Browns traded three picks to the Bills for Buffalo's choice in the supplemental draft, and they selected Kosar with that pick. Right before the season, the Browns signed free-agent veteran Gary Danielson, hoping to keep Kosar on the bench during his rookie season.

Danielson opened the season with rookie fullback Kevin Mack and second-year runner Earnest Byner in the backfield. The Browns acquired Mack, a bruising fullback, in the 1984 supplemental draft after Mack spent the 1984 season in the USFL. Byner was a second-year halfback who averaged over five yards per carry with the Browns in 1984.

Schottenheimer knew that Cleveland's success would hinge on the defense's play. The Browns still had one of the most talented linebacking units in the league with returning veterans Matthews, Cousineau, and Banks. Cornerback Hanford Dixon was one of the best cover men in the league, and his backfield mate, Frank Minnifield, was emerging fast. Carl "Big Daddy" Hairston and Bob Golic provided excellent line support.

The defense's emotional leader was Dixon. During training camp, Dixon would run around the practice fields and bark at his fellow defenders, trying to pump them up. Fans, watching the practices from the sidelines, took off with the concept of the Dog Defense, which quickly became the *Dawg* Defense. The players fed off this, and began using the term to describe themselves in interviews.

Cleveland's "run first, pass hardly" strategy worked to near-perfection in the first game against the St. Louis Cardinals, and the Browns gained 176 yards on the ground. Although they trailed, 17-3, in the fourth quarter, the Browns scored three consecutive touchdowns to take a late 24-17 lead with just 38 seconds left. The Cardinals tied the game at the end of regulation, and then won in overtime, 27-24.

The Steelers came to town in the second week and the Browns out-gained Pittsburgh 145-54 on the ground, and smothered the Steelers, 17-7. Dallas beat the Browns, 20-7, the next week, but the Browns let the game slip away as Danielson threw two costly interceptions and Dallas fooled Cleveland's defense on a trick play that resulted in a Cowboy touchdown. Although the Browns' record stood at 1-2, the Dawgs and the running game were playing better.

The dynamic running game blasted San Diego's defense in week four to the tune of 276 yards, with Mack and Byner accounting for 213 of them. After San Diego took a quick 7-0 lead, the defense shut down Dan Fouts and the offense, while Cleveland's offense took over the game. The Browns evened their record at 2-2 with the 21-7 victory, and suddenly the playoffs did not seem so far-fetched.

Rookie Bernie Kosar made his NFL debut seven days later against the Patriots when starting quarterback Gary Danielson injured his rotator cuff in the game. Facing a 20-17 deficit, Kosar calmly led the Browns on a fourth quarter comeback drive, culminating in a Mack touchdown. The defense then twice held New England on 4th-down tries deep in Cleveland territory to preserve a 24-20 victory.

Kosar heavily relied on Mack and Byner to win his first NFL start against the Oilers, 21-6. Each runner scored, and the two combined for 163 total yards. Kosar contributed as well, throwing a 68-yard touchdown to Clarence Weathers. As usual, the defense dominated, sacking Warren Moon seven times and forcing two interceptions.

The 4-2 Browns lost their next four games, including their 16th in a row at Three Rivers Stadium where the Steelers kicked the winning field goal with nine seconds left. Kosar played well during the losing streak, but not well enough to win as the Browns scored more than 10 points only once during the four games. With Danielson injured, teams successfully keyed on Cleveland's running game, limiting the effectiveness of the offense.

The Browns already clinched the AFC Central crown before their last game with the New York Jets started. Although they were only 8-7, Cincinnati and Pittsburgh both lost in earlier games to hand the title to the Browns. History was the only item left undecided in that game. Earnest Byner rushed for 901 yards in the first 15 games, while Kevin Mack gained 1104 in the same stretch. If Byner gained 99 yards against the Jets, the Browns would join the Dolphins as the only team with two 1,000-yard rushers in the same season. On the last play of the game, the Browns trailed the Jets 37-10 with time enough for one more play. Byner needed seven more yards to earn his 1,000, and on the last play, he picked up nine to finish with 1,002.

The Browns faced Dan Marino and the Dolphins' high-scoring offense in the AFC divisional playoffs. Marino, who set records for TD passes (48) and yards (5,084) in 1984, was the best quarterback in the NFL, played behind the best line, and had two of the best receivers in the game, Mark Duper and Mark Clayton. The Dawgs were up to the challenge, though, and held the Dolphins to a single, 51-yard field goal in the first half. The Browns led, 14-3, at halftime, and Byner extended the lead in the third quarter on a 66-yard touchdown run.

The defense also battled the warm temperatures in Miami all day, and finally tired in the second half. Marino led the Dolphins on two scoring drives in the third quarter to climb back into the game, 21-17. Late in the game, Miami drove down the field on an 8-play, 73-yard drive, and finished the Browns off with a touchdown to win the game, 24-21.

There's a Gleam, Men

Bernie Kosar grew up quickly in 1985, and opened training camp as the starting QB, converting Gary Danielson to a safety net rather than a mentor. With a mature Kosar at the helm, the Browns spent their top draft pick, a second rounder, on wide out Webster Slaughter to give Bernie a deep target. Reggie Langhorne, a 7th-round pick from 1985, supplanted Clarence Weathers at the other wide receiver spot, giving the Browns an added dimension on offense— the passing game.

Cleveland's first test of the year was a tough one, the Super Bowl champion Chicago Bears. Although Chicago's defense was stellar, the Browns' defense struck first when Al Gross recovered a Chicago fumble in their end zone for a quick 7-0 lead. The lead only lasted a few seconds; Dennis Gentry returned the proceeding kickoff for a touchdown to tie the game. The Bears rattled off two more scores extending their lead to 21-7. The Browns did not relent, though, and eventually battled back to within three, 34-31. The Bears scored a late touchdown to seal the game, 41-31, but Kosar threw for almost 300 yards and completed almost 60 percent of his passes.

The Browns won four of their next five, including an historic contest on October 5. The Browns traveled to Pittsburgh in week five to face the Steelers and The Jinx, now 17 years old. As expected, an early 10-0 Cleveland lead evaporated in the second quarter on two Pittsburgh touchdowns, but Gerald "Ice Cube" McNeil returned a kickoff 100 yards, propelling the Browns back to the lead right before halftime, 17-14. The teams battled throughout the second half, and the Browns took the lead midway through the fourth quarter, 27-24. Cleveland fans watched through covered eyes for the rest of the game, waiting for the meltdown that never came. Since 1970, the Steelers outscored the Browns 425 to 228 in Three Rivers Stadium, but on October 5, 1986, Cleveland finally bested Pittsburgh, 27-24.

The Browns won eight of their last nine games to finish their best season since the 1960s with a 12-4 record. The twelve wins were best in the AFC, so the Browns earned home field advantage throughout the playoffs for the first time since 1980. Kevin Mack and Earnest Byner

suffered nagging injuries all year, and only played seven quarters together during the season. Mack led the team in rushing with just 665 yards, and Byner finished third with 277. Bernie Kosar rapidly progressed as the rushing game declined, and he developed into one of the games most intelligent quarterbacks in two short years.

Browns fans treated the playoffs with cautious optimism in 1986. Since 1965, they witnessed stalwart teams fall apart in big games. The 1965 team recorded an 11-3 season, and then lost to the Packers in the championship. Ten-win campaigns in 1968 and 1969 ended in humiliating title game blowouts. The 1971 club won its last five games but was trounced by Baltimore in the opening round. Then, of course, there were the 1980 Kardiac Kids, winners of nine last-minute games; they lost to a wildcard team with 41 seconds to go.

Schottenheimer did not buy into the attitude. From the day he was hired, he set one goal for the Browns: a Super Bowl championship. Marty's confidence extended to his players, and so he sent his troops to battle with a pre-game speech that lasted all of ten seconds: "There's a gleam, men," he said. He paused, instructed them to capture that gleam, and sent them off to battle the Jets.

New York set the tone for a wild game early when Coach Joe Walton called a trick play. Ryan handed the ball to fullback Freeman McNeil. McNeil took off on an apparent sweep, but stopped, then pitched the ball across the field back to Ryan, who fired a 42-yard touchdown to the wide-open Wesley Walker. Cleveland answered by driving straight down the field on their next possession, quickly tying the game three minutes later. The teams exchanged field goals before the half, and went into the locker room tied at 10.

The Jets scored the only points of the third quarter on a 37-yard field goal, and the fourth quarter wore on with the Browns trailing 13-10. Finally, Kosar found some rhythm on offense, and drove the Browns down the field, all the way to the New York two-yard line. On third-and-goal from the two, Kosar fired a pass to Slaughter, who was double-covered on the play. The Jets intercepted the pass; the comeback drive was dead.

After giving up a couple of first downs, the Dawgs stiffened and forced a punt. Kosar led the Browns back onto the field, determined to redeem his previous mistake. The drive only lasted one play because Kosar, who had the NFL's lowest interception percentage, threw another interception. McNeil took the next play to the house, breaking through the defense for a 25-yard score. Although homemade signs around Municipal Stadium attempted to exorcize the demons from 1980, Red Right 88 seemed to haunt the Browns on this day. The Browns trailed, 20-10, with little more than four minutes left in the game.

Much of the sellout crowd began to leave with all hope lost. Even some players questioned the feasibility of a comeback, but the young Kosar was not one of them. "We're going to win this game," he insisted. He then took the field to make good on his prediction, though the Jets would make it tough for him.

New York smothered the immobile Kosar on the first play, and an incompletion on the second would have set up third-and-24 for the Browns, but officials flagged Jets lineman Mark Gastineau for roughing the passer, giving the Browns a first down and a new life. Kosar got to work, driving to New York's three-yard line. This time, the Browns ran the ball in, and pulled to within three immediately after the two-minute warning. With time running short, Cleveland tried an onside kick, which failed. The defense held New York to a three-and-out, giving Kosar one more shot. A deep pass to Slaughter and a New York penalty set up Mark Mosely's game tying field goal in the final seconds, and the game went to overtime.

The Browns made a push early in overtime when Kosar audibled and connected on a deep pass with Reggie Langhorne. The Browns had the ball at the New York five-yard line, and sent Mosely out for the winning field goal—which he remarkably missed. The 36-year old kicker, on the hook if the Browns lost, dejectedly walked back to the sideline. The Jets could not move the ball against the Dawg Defense in overtime, and the extra period ended without a score.

For the third time in NFL history, a second overtime was played. The Browns made another offensive push, and drove into field goal range once more. Mosely, like Kosar, had a chance for

redemption, and like Kosar, made good on that chance, connecting on a 27-yard kick to give Cleveland its first NFL playoff win in 17 years. Nev Chandler, the Browns' radio broadcaster, described the moment as "pandemonium," and the 30,000 or so fans that stuck it out agreed. In one year, the Browns erased 17 years worth of stadium jinxes and playoff curses, and were just one win away from the Super Bowl.

Bernie and the Browns hosted the Denver Broncos one week later. The two AFC heavyweights exchanged blows through the first half of the conference championship game, which ended like the previous week's game, knotted at 10. Denver, like the Jets, scored the only three points of the third quarter, and the Browns entered the fourth trailing by a field goal. Unlike the previous week, Kosar did not throw a pair of interceptions; instead, he coolly led the offense down the field where Mosely tied the game. On Cleveland's next possession, Kosar hit Brian Brennan on a long route down the sideline, and Brennan broke a tackle near the goal line to give the Browns a 20-13 lead. Denver muffed the ensuing kickoff, and barely covered the ball at their own two-yard line.

Elway came onto the field with 5:32 remaining, 98 yards away from tying the game. John Elway proceeded to lead his offense on one of the most remarkable touchdown drives in the history of the NFL. With each completion, scramble, and third-and-forever conversion, fans quieted. The 15-play, 98-yard drive ended five minutes and one second after it started, with Elway hitting Mark Jackson on a slant pattern to tie the game.

The touchdown deflated the team, the fans, and the city. Denver's overtime win was inevitable; they held Kosar's offense to a punt, drove down the field, and nailed the game-winning field goal. Some fans swear that Rich Karlis' kick was wide to the left as it sailed over the upright, but that was little consolation for a crushing defeat.

The only solace for Browns fans was the motto they lived by for the last 22 years, which cruelly applied to the off-season ahead: There is always next year.

The Gleam Fades

Undaunted by "The Drive" in 1986, the Browns went back to work in 1987—for a short while. Just as they did in 1982, NFL players conducted a labor strike over free agency rights after the second week of the season. The Browns lost their season opener in New Orleans, and then won their home opener against the Steelers before the work stoppage. The strike wiped out all NFL games for the September 27 weekend, the date that he Denver Broncos would have returned to Cleveland.

Many NFL owners still felt the financial impact of the 1982 strike, which lasted 57 days. In order to gain leverage on the players' union, teams signed replacement players to play in week four, and the league stated that the games would count in the final standings. The tactic eventually worked; after the replacements, or scabs as they were known, played in week four, the "regulars" began to cross the picket line and return to their teams. The strike lasted only three weeks, and all 28 teams resumed the schedule with regular players in week seven.

Cleveland's scabs went 2-1 with the help of Gary Danielson, who crossed the picket line and played in the third strike game. Their only loss was to the Oilers, whose replacements also tallied a win in Denver. Still, the two wins set Cleveland up with a 3-2 record, and the regulars came back to win four of their next five, pushing the Browns into first place in the Central with a 7-3 record.

The Browns lost in San Francisco to Joe Montana and the 49ers in a 38-24 shootout, reminiscent of the Browns' battle with the Bears one year earlier. The next week, The Browns and Colts battled in a defensive struggle. Indianapolis scored three field goals in the second quarter to take a 9-0 halftime lead, and the Browns responded with a Kosar-to-Brennan touchdown. Browns kicker Jeff Jaeger missed a go-ahead field goal later in the third, though, and Earnest Byner fumbled away the winning touchdown in the fourth in a 9-7 loss.

The Browns won their final three contests to better the Oilers by a game and secure their

third consecutive playoff appearance with a 10-5 record. Meanwhile, the AFC West's Broncos finished at 10-4-1 to earn the home-field advantage throughout the playoffs. Many fans argued to throw out the scab games, but "the playoff seedings would have been [exactly] the same," anyway, according to researcher Roger Gordon.

In the divisional playoffs, the Browns beat the Colts by 17, and the Broncos pounded the Oilers by 24 to set up the rematch of the 1986 AFC Championship game. This year's heavyweight bout took place in Denver, and Browns fans hoped to avenge last year's heartbreaker. Cleveland's prospects did not look good early as a frenzied Broncos team rushed out of the locker room and raced to a 21-3 lead early in the second. That lead lasted through halftime, but the Browns' offense caught fire in the third quarter. Kosar drove them down the field for an early 3rd-quarter touchdown, but Elway immediately answered with an 80-yard catch-and-run score. Earnest Byner scored the next two touchdowns for the Browns, first on a 32-yard catch, and then on a four-yard run. Despite a Denver field goal, the Browns climbed back into the game, and only trailed, 31-24, to start the fourth. Tension built in the fourth, but neither quarterback flinched as Kosar tied the game at 31 with a four-yard toss to Webster Slaughter that capped an 86-yard drive, and Elway answered with a 20-yard toss that finished a seven-minute drive.

Denver led 38-31, and Cleveland had the ball 75 yards away from a tie with 4:01 remaining. Kosar then orchestrated what was sure to be called The Drive II, side-arming passes downfield. The Browns offense lined up at the eight-yard line, down by seven, with a minute and change left on the clock. Byner took a handoff and darted toward the end zone, but then he fumbled at the five-yard line; the Broncos recovered, and won the game. The Drive II became forever known as "The Fumble." There is always next year.

The season opener in Kansas City was a disaster for the Browns and set an ominous tone for 1988, even though they won, 6-3. Kevin Mack, Frank Minnifield, Bob Golic, and Gerald McNeil all were hurt in the game, but the biggest blow came when Lloyd Burress crushed Bernie Kosar on a blitz in the first quarter, injuring his throwing arm. Gary Danielson finished the game for Kosar, who was out for six weeks with the injury.

The Browns rotated quarterbacks for the rest of the season. Danielson broke his ankle in week two against the Jets. Third-stringer Mike Pagel, the placekick holder, performed admirably for the next three weeks, but broke his collarbone making a tackle on a blocked field goal against Seattle. Thirty-eight year old Don Strock, signed after Danielson was hurt, was forced into action, finished the Seattle game, and beat the Eagles the next week before Kosar finally returned from his opening-game injury.

The quarterback carousel kept Cleveland's playoff hopes alive, managing a 4-3 record. Kosar returned to guide the Browns to five wins in the next seven games, but hurt his knee in week 15 against the Dolphins. The Browns lost, and entered the last game of the year needing a win to reach the playoffs. Strock took over again and beat the Oilers, 28-23, by throwing for 326 yards, but left the wildcard rematch with a hand injury—number five for Cleveland quarterbacks—and the Browns lost the game.

The offense sputtered most of the season, partially because offensive coordinator Lindy Infante left for the Packers before the season, and partially because of the injuries at quarterback. Art Modell wanted an offensive coordinator for the 1989 season because Schottenheimer's play calling became too conservative as the season wore on. Schottenheimer defended his scheme, mockingly dubbed "Marty Ball," citing injuries as the reason for the decline. Just as Modell and Paul Brown had been in 1962, owner and coach were at an impasse.

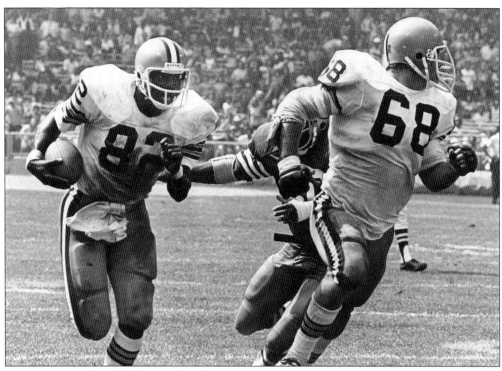

Ozzie Newsome (with ball) was Cleveland's second selection in the first round of the 1978 NFL Draft. The Browns acquired the pick in one of the best trades in team history by sending fledgling quarterback Mike Phipps to the Bears for the pick that eventually led to Newsome. "The Wizard of Oz" played 13 seasons with the Browns, and when he retired in 1990, he was the all-time receptions leader for tight ends in NFL history, and ranked fourth among all receivers. (Courtesy of the Cleveland Press Collection, Paul Tepley.)

Clay Matthews had a flair for the razzle-dazzle play. If Matthews recovered a fumble or intercepted a pass, he always looked to pitch the ball. This came back to sting the Browns against the Oilers in 1989 when in a game that determined the AFC Central division championship, he lateraled the ball to a teammate who fumbled it. Warren Moon threw a 27-yard touchdown strike on the next play giving Houston a 20-17 lead, but Matthews was taken off the hook when the offense drove down the field to score a touchdown and win the game. (Courtesy of Vince LaValle.)

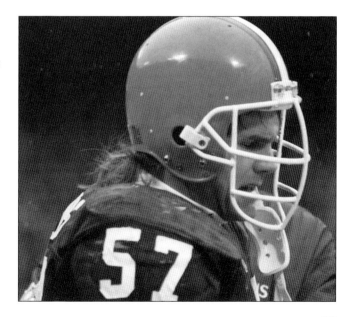

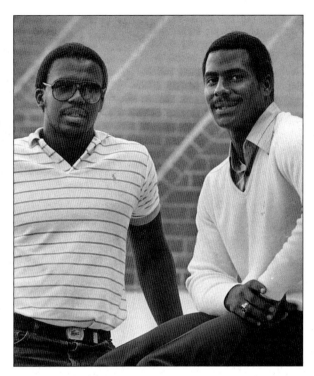

The Browns selected linebacker Chip Banks (right) with the third overall pick in the 1982 draft. Banks earned a trip to the Pro Bowl in four of his five seasons with the Browns, including his rookie year of 1982. Banks was a member of the best linebacking unit in the NFL, combining with Clay Matthews, Tom Cousineau, and Dick Ambrose. He was traded in 1987 after a contract dispute with Art Modell, and played five more seasons in the NFL. (Courtesy of the Cleveland Press Collection, Daniel Ho.)

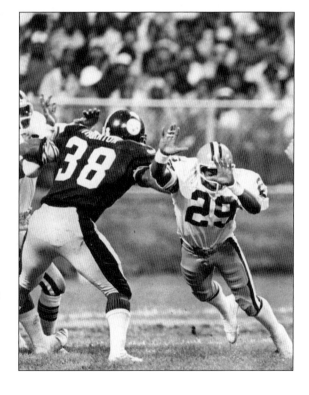

Hanford Dixon (#29) tries to block a Pittsburgh kick. His breakout game came against the Steelers in 1982 when he intercepted three passes, recorded a sack, and forced a fumble. His last interception came as the Steelers were driving for the go-ahead score late in the game and preserved a 10-9 Browns victory. Dixon went on to enjoy a spectacular career, earning All Pro honors in 1987, 1988, and 1989. (Courtesy of the Cleveland Press Collection.)

Dixon inadvertently invented Cleveland's "Dawg Defense" during training camp in 1984 by running around barking like a dog during practice. Before long, fans in Municipal Stadium's bleacher section began showing up for games wearing dog masks, and cheered on the team with Dixon's distinctive bark. "The Dawg Pound" was born, and tickets for the worst seat in the house became some of the most sought-after in the stadium. The Dawg Pound was one of the rowdiest sections of fans in any sport, and actually won a game for the Browns against the hated Broncos. Early in the fourth quarter of a 1990 game, fans from the bleachers began pelting John Elway and the Denver offense with batteries and eggs, among other things, forcing the referee to switch sides of the field. The Browns, with the wind at their back instead of in their face, drove down the field late in the game and kicked a game-winning field goal that just barely passed the crossbar. The unmistakable leader of the Pound was hefty John "Big Dawg" Thompson, who attended every home game wearing his #98 jersey, orange helmet, and of course, his Big Dawg mask. Though he rarely showed his face, he became one of the most recognizable fans in all of sport, and used his popularity following the 1995 season, testifying before Congress in a futile attempt to prevent Art Modell from moving to Baltimore. (Courtesy of Vince LaValle.)

Bernie Kosar grew up in the Youngstown area loving the Cleveland Browns. After leaving Youngstown to star at Miami (FL) University, he wanted to play for the Browns as much as Browns' management wanted Kosar to return home. After purpously declaring his eligibility for the NFL after the regular college draft, Cleveland sent three draft picks (first, third, fifth round selections) to Buffalo for their pick in the supplemental draft. The Browns picked Kosar, and never regretted the lost choices. Kosar even had his own song, "Bernie, Bernie," performed by "The Bleacher Bums." (Courtesy of Vince LaValle.)

Bernie Kosar was so popular in Cleveland that he had his very own candy bar! Prices varied around the Cleveland area, but fans could usually purchase one of these milk chocolate bars for under $3.00. Kosar fanatics could also opt into the Bernie Kosar Fan Club for $9.95/year, entitling them to letters from Kosar, stickers, and an annual, personalized birthday card from the popular quarterback. The fan club stopped taking memberships and renewals in 1993, but continued to send birthday cards through 1994.

The Browns started the 1984 season 1-7, so Art Modell fired Sam Rutigliano. He handed the team over to Marty Schottenheimer, who rallied the Browns to a 4-4 finish. That impressive second half was enough to convince Modell to give Schottenheimer the full-time job starting in 1985, and Marty led the Browns to four straight playoff appearances, including three AFC Central Division Championships, in his four years as coach. (Courtesy of the Cleveland Press Collection, Paul Tepley.)

Kevin Mack was a bruising fullback that reminded long-time Browns fans of Jimmy Brown early in his career. Mack set a Browns' rookie rushing record in 1985, picking up 1,104 yards on the ground, but he never achieved the same success in his career after that. Injuries plagued him for the next three seasons, and then in 1989 he served time in prison for drug possession. Mack attempted to come back in the next three years, but never regained his rookie form. (Courtesy of Vince LaValle.)

Bernie Kosar's favorite target was wide receiver Webster Slaughter. Slaughter, a second round draft pick from San Diego State, scored 28 touchdowns for the Browns in six seasons, but gained more notoriety for his celebrations afterward, which included ball spinning, dancing, and choreographed high-five acts with fellow wideout Reggie Langhorne. "WebSTAR" painted his shoes orange before a Monday Night Football game against the Bears, and caught a 97-yard touchdown in the game. Slaughter sued for his free agency in 1991, and eventually won the case. He ended his career with the Chargers in 1998. (Courtesy of Vince LaValle.)

Some fans express their beliefs through words at Cleveland Municipal Stadium while police halfheartedly attempt to rip down the sign. Art Modell, whose number one wish was to be the most loved man in Cleveland, suffered hit after hit in public relations, starting with his dismissal of Paul Brown. Among Modell's gaffs were: blacking out the 1964 championship game, a very public lawsuit with the Cleveland Indians, three lawsuits with Browns' minority owner Bob Gries, and contract disputes that led to the exit of star players like Webster Slaughter, Chip Banks, Lyle Alzado, Reggie Langhorne, and Hanford Dixon. (Courtesy of the Cleveland Press Collection.)

EIGHT
Diminishing Skills
1989–1996

One AFC Central Championship

Browns offensive coordinator Lindy Infante left the club following the 1987 season to become the head coach of the Green Bay Packers, so Marty Schottenheimer called the offensive plays in 1988. The offense struggled through four quarterback injuries, yet the Browns made the playoffs in 1988. Cleveland lost in the wildcard game to the Oilers, as Don Strock, the fourth-string quarterback, left the game with an injury.

Art Modell wanted changes to his club for the 1989 season. He and Schottenheimer met days after the playoff loss to discuss, among other things, the coach's new offensive play caller. Marty refused to hire a coordinator, and quit the team altogether. Modell described the situation as a mutual separation. Schottenheimer's resignation sent shockwaves through the city; he was the coach who lifted the Browns from the AFC Central basement to the penthouse.

Modell replaced Marty with defensive guru Bud Carson, who was the architect of the great "Steel Curtain" defense of the Pittsburgh Steelers in the 1970s. Despite Carson's impressive résumé, this was his first head-coaching job in the NFL. Incidentally, Carson promoted quarterbacks' coach Marc Trestman to offensive coordinator, satisfying Modell.

Short-Lived Success

The Browns traveled to Three Rivers Stadium for the 1989 season opener and obliterated the Steelers 51-0. The defense recorded eight turnovers, seven sacks, and scored three of the six touchdowns in the game. The game marked Cleveland's fourth straight win in Pittsburgh after 16 consecutive losses, and made Marty Schottenheimer a distant memory.

The Browns split their next two games, and then hosted the hated Broncos in week five. In the fourth quarter, the Broncos offense was backed up to its goal line when fans started pelting Elway and his teammates with batteries and other debris to such an extent that the officials ordered the Broncos to continue play at the other end of the field. The game was tied, 13-13, in the closing moments when, ironically, Denver *fumbled* and the Browns put together a *drive* that set up a Matt Bahr field goal to win the game. Bahr's 48-yard kick barely cleared the crossbar, and it probably would not have been long enough had the teams not switched sides earlier, giving the Browns the wind at their backs. Nevertheless, the Browns escaped with a 16-13 win.

The Browns ripped off a 4-game winning streak in the middle of the season, and hosted the Chiefs in week 11. This was perhaps the most important game of the year for Carson because Schottenheimer was now the coaching the Chiefs, and Modell badly wanted to beat his former employee. The teams, to nobody's surprise, battled all afternoon in a defensive struggle. When the dust cleared, neither side won; the two defensive coaches battled to a 10-10 stalemate. It was the first tie for both teams since 1973, when, coincidentally, they tied each other.

The Browns lost their next three, but won their last two contests to edge out Houston by a half-game for the Central Division title, and opened the playoffs by hosting the explosive Buffalo Bills at Municipal Stadium. The Browns trailed for most of the first half, but scored a pair of touchdowns in the third quarter to take a 10-point lead. The teams traded touchdowns for most of the second half as Cleveland's lead fluctuated between seven and ten points. Buffalo scored a touchdown with four minutes to go, but missed the extra point, and trailed, 34-30.

The Browns' offense could not run out the clock, which gave the Bills one last opportunity for the win with 2:41 remaining. Buffalo methodically marched downfield, but needed a touchdown rather than just a field goal because of the missed point-after-touchdown attempt. With 14 seconds left, Bills quarterback Jim Kelly lofted a pass to a wide-open Ronny Harmon in the end zone, who inexplicably dropped the sure touchdown. On the next play, Kelly fired a pass over the middle, but a Clay Matthews interception preserved the win for Cleveland.

Cleveland advanced to the AFC Championship game for the third time in four years, and like the previous two meetings, they faced John Elway and the Denver Broncos. The Browns trailed through the entire game, but in the third quarter, Kosar led the Browns on two quick touchdowns to cut Denver's lead to 24-21. The Browns would not score again, though, and lost their third title game to the Broncos in four years, 37-21.

Cleveland's fortunes turned for the worse in 1990. The Browns won their opener against the Steelers, but lost six of their next seven as both the offense and defense struggled. Art Modell, already miffed at the losing season, pulled the plug on Carson when the Bills thrashed the Browns, 42-0, in week nine. Modell promoted offensive coordinator Jim Shofner to Carson's old spot for the rest of the year, and the Browns finished with their worst record in franchise history, 3-13.

The Enemy among Us

The once powerful Browns were suddenly a mix of old veterans and unproven talent, so the next head coach would have to rebuild them in order to make a serious Super Bowl run. Although Art Modell considered interim coach Jim Shofner for the head-coaching job, he instead chose Giants' defensive coordinator Bill Belichick. Belichick, the team's fourth coach in four years, was a popular choice amongst the local media, and Modell was extremely pleased with the hire, proclaiming that Belichick would be "the last coach I hire."

The rookie head coach's first task was to rebuild the Browns' aging defense, where only two

members of the original Dawgs, Clay Matthews and Frank Minnifield, were still with the team. Belichick selected safety Eric Turner with the second overall pick in the draft, and then spent five other selections on defense as well. Vince Newsome, a veteran safety previously with the Packers, also joined the team.

Bernie Kosar, playing without injury for the first time in three years, returned to his old form in 1991, throwing for almost 3,500 yards and 18 touchdowns. The Browns' running attack was horrid, though. Kevin Mack's 726 yards accounted for more than half of the entire team's totals and did not remind anyone of the great 1985 Mack-Byner tandem that gained over 2,000 yards. Still, the Browns doubled their win total from the previous year, finishing 6-10.

The Browns underachieved in 1992, finishing the season 7-9. Browns fans expected a return to the playoffs, but a three-game losing streak at the end of the season dropped them out of contention. Belichick began to take some hits in the press as Cleveland's lackluster offense scored less than 20 points in 11 of the 16 contests. Kosar fractured his ankle in week two, and then broke it again in the season finale.

Kosar underwent off-season surgery on his troublesome ankle after that game, and team doctors gave him a clean bill of health for the 1993 season. Management lauded Kosar with a 9-page spread in the team's annual press guide, claiming, "The savvy 'veteran' of 29 could become the most prolific passer in team annals this season," and asked the popular quarterback to take a pay cut so they could sign more offensive help for him. The immobile Kosar agreed, knowing that a stronger offensive line would help to keep him off the Injured-Reserved list.

Instead of revamping the team's offensive line to insure good quarterback play, the Browns signed Vinnie Testaverde to back Kosar up. Belichick and his front office staff also fine-tuned the roster by adding center Steve Everitt via the draft and signing free agents Carl Banks and Jerry Ball on the defensive side.

The Browns completed the first half of the season with a 5-3 record, good enough for the Central Division lead, but trouble surrounded the club. Belichick started, but benched, the team's "savvy veteran" for four consecutive games in favor of Testaverde, and sat Kosar altogether for another game. Although Marty Schottenheimer's refusal to give up calling plays led to his dismissal, Belichick called the plays in 1993, and Kosar disagreed with his strategies. The Browns lost in week eight against the Broncos, 29-14. Late in the fourth quarter, Kosar disregarded a play sent in from the sidelines and diagrammed his own in the dirt at Cleveland Stadium. The quarterback called for a deep pass play, which went for a touchdown. Belichick was livid, and the two intensely argued on the sidelines afterward.

As fans were analyzing the tirade on the Monday following the game, the Browns called a press conference to announce Kosar's release, citing "diminishing skills" as the main reason for the move. Repercussions from media and fans were intense, with Belichick taking all of the heat for the move. Bill Belichick, once the savior and "defensive genius" of the Browns, became public enemy number one in Cleveland, and he stayed that way for the duration of his stint as coach.

Kosar signed with the Dallas Cowboys three days later. Angry Browns fans showed the team's management how popular Kosar was by making Bernie's #18 Dallas jersey the number one selling jersey in Cleveland. Kosar played an instrumental role for the Cowboys when he substituted for the injured Troy Aikman and won two games as the starter. The Cowboys went on to win the Super Bowl; Bernie Kosar took the final snap, knelt down, and earned his elusive ring. Meanwhile, the Browns averaged less than 20 points per game for the rest of the season, and went 2-6 after cutting their veteran quarterback. The media pounded Belichick for the lack of production in Cleveland while Kosar threw touchdowns in Dallas.

The Browns improved to 11-5 in 1994, won a playoff game, and sent seven players to the Pro Bowl. Still, Belichick could not overcome the Kosar debacle, and continued to be a very unpopular figure. The media berated him for horrid play calling, lack of charisma, and the team's three losses, two in the regular season and one in the playoffs, to the Steelers in 1994. Art Modell steadfastly supported his coach though; Bill Belichick was here to stay.

A Heartbreaking Loss

The Browns split their first eight games of the 1995 season with Vinnie Testaverde under center, but Browns fans lost all hope on the eve of the team's ninth game against the Oilers. On November 5, 1995, in a radio interview with Mike Snyder, Art Modell announced that he was in talks with the city of Baltimore, and that he planned to move the Browns to Maryland at the conclusion of the season.

The interview lasted for about an hour, but offered few answers to stunned fans and reporters. Modell cited "a dramatic deterioration of the financial condition of the Browns," but never addressed specifics. He flatly stated that the situation was beyond his control, and the events that were set in motion would be carried out regardless of what happened in the future.

The truth was that Modell really was out of money, and his precarious financial situation stemmed from the 25-year stadium lease agreement that he arranged with the city in 1975. Modell, knowing that Municipal Stadium cost the city over $300,000 annually to run, agreed to incur the losses in exchange for quasi-ownership rights to the building. Modell also agreed to give the city a percentage of any profits he realized and to make capital improvements on the aging stadium as well. He financed the entire deal with variable-rate loans from area banks.

Modell created a company, the Cleveland Stadium Corporation or StadiumCorp, to run the stadium, negotiate lease agreements with the Indians and Browns, and solicit special events. StadiumCorp effectively managed the venue for years, but costs escalated out of control in the 1980s. Unforeseen circumstances like rising interest rates, poor baseball attendance, and two NFL strikes forced StadiumCorp to borrow more money, but StadiumCorp survived, in order to continue managing the venue.

Modell tried to sell StadiumCorp to the Browns in the 1980s in order to infuse some cash into the deal and pay the outstanding loans of the company, but Bob Gries, a minority owner of the Browns, sued Modell over the deal. Gries did not want to take on the debt or risk associated with the management company, and after three lawsuits, Gries finally won. StadiumCorp continued operations, narrowly missing profitable years throughout the decade.

Art Modell engaged in battles with the city of Cleveland throughout the decade as well. City officials constantly scrutinized the StadiumCorp deal to make sure it was fair for the city, and Modell received bad publicity over the agreement consistently. The Browns' owner, who flaunted his Republican ties and views, felt the Democrats that occupied city council and the mayor's office ostracized him because of his political affiliations. Modell asked for a 10-year extension on the StadiumCorp deal in 1988, but the city would not agree.

The Indians, who seemingly threatened to move out of Cleveland every other week if a new, baseball-only stadium was not built, finally got one on May 8, 1990. Cuyahoga County residents passed the Gateway project that would finance a new baseball-only stadium for the Indians and basketball arena for the Cavaliers. When the Indians moved out of Municipal Stadium and into Jacobs Field in 1994, StadiumCorp lost its biggest customer. A series of special events that summer, such as motocross, a fair, and the circus, were not quite enough to make up for the loss of baseball.

Modell eventually reached his borrowing limit in Cleveland as his debts outgrew his considerable assets. When unrestricted free agency for players came, salaries skyrocketed, and Modell needed to borrow $5 million in order to pay wide receiver Andre Rison's signing bonus. Still, Modell thought that if his 1994 Browns could reach the Super Bowl, the team would make enough money to pay off all of the debt.

Unfortunately, the Steelers knocked the Browns out of the playoffs in the divisional round that year, which put Modell in serious financial trouble. StadiumCorp had a disastrous 1995, and Modell began to explore a new city for his team. He visited the city of Baltimore, and began negotiating the deal that would move the Browns to Maryland. Word of the impending deal began to leak back to Cleveland, though Mayor Michael White did not believe the rumors, and refused to negotiate with Modell.

The rumors turned out to be quite real; Baltimore and the state of Maryland forked over a

king's ransom to get the Browns. They agreed to build the Browns a new stadium and training facility, settle Modell's StadiumCorp and Browns debt, and pay to move the entire organization from Cleveland to Baltimore. All told, Modell's total windfall exceeded $280 million.

By the time Mike Snyder conducted his interview on November 5, Modell had already signed the deal that would move the Browns to Baltimore. Mayor White, fearing for his political career, initiated a series of lawsuits aimed at keeping the Browns in Cleveland, stating that Modell could not break the team's lease, which ran through the 1998 season. Modell had no intention to stay, telling his staff that if the courts forced the Browns to play in Cleveland, they would fly in from Baltimore on Sunday morning and fly out Sunday night immediately after the game. Clevelanders could only watch in horror as the court battles took place in Cleveland while Modell received a hero's welcome in Baltimore.

Only one day after the original announcement, 57,881 fans filed into Cleveland Municipal Stadium like zombies to watch the Oilers bulldoze the Browns, 37-10. It was the most meaningless game the team ever played. "It was more like attending a funeral than a football game," one fan mumbled.

After that game, the team lost five more, and prepared for their last game ever at Cleveland Municipal Stadium against the Cincinnati Bengals. On December 17, 1995, the Browns treated the home crowd to one last victory, 26-10. Players walked around the edge of the field, hugging and exchanging high fives with fans for hours after the final gun.

The legal battle for the right to the Browns continued well after the season ended. In February of 1996, the NFL brokered a deal with the City of Cleveland that allowed the Browns to move to Baltimore. The deal called for Modell to pay $11.5 million to Cleveland, which would cover the remaining stadium lease, legal fees, and lost income taxes through 1998. The NFL agreed to place a team of the league's choosing, existing or expansion, in the city by the 1999 season if a new stadium was constructed. In exchange, Cleveland agreed to drop its lawsuits against Modell.

An additional part of the agreement was that Modell also agreed to place the name "Browns," the orange and brown colors, and the team's records into a trust that the NFL would transfer to the city's next team owner. Although Clevelanders viewed this part of the deal as a win, Modell finally shed himself of the last ties he had to Paul Brown, the colors that he picked, the records he achieved, and the team that bore his name. All it cost the embattled owner was his legacy.

Modell's ego became his downfall when he thought he could turn a profit on a building that the city had taken a loss on since its construction. His reckless spending, political posturing, and mismanagement of personnel all served to feed his ego, but destroyed his finances. When there was no longer a way for him to survive as the owner of the Cleveland Browns, he shockingly moved the civic treasure out of town, opting to retain ownership rather than sell it to someone who could keep it in Cleveland.

Fans, politicians, and the media made one mistake in dealing with Modell. They did not believe that he could or would move his team from the city. After all, The Browns belonged to Cleveland and Clevelanders, not Art Modell. Sadly, everyone involved came to realize that the team really did belong to the man who borrowed $4 million to buy it in 1961, and that man did not have to sell it, or ask permission to leave.

Upon the announcement of the agreement with the NFL in 1996, Mayor Mike White declared victory for the City of Cleveland, though Browns fans hardly agreed. The final agreement called for Modell to repay incurred expenses and all future losses in revenue due to the move, so the city did not suffer from the loss of the team. The fans suffered, though, as they watched Modell's new team, the Baltimore Ravens, turn their fortunes around and eventually win the Super Bowl championship in 2000. In the end, White won since he was able to rid the city of Modell, and Modell won as he attained a new stadium and a championship; but the fans lost a Super Bowl title and the team they had cheered on for half a century.

Michael Dean Perry was the leader of the second generation of Dawg defenders. Michael Dean was well over 300 pounds, but was still one of the quickest linemen in the league. Sometimes he reacted to the snap so quickly that he would knock the ball out of a center's hand before it reached the quarterback! The five-time Pro Bowl player was such a force that in a 1989 contest, Kansas City players tore the numbers off his jersey while holding him on virtually every play, though no flags were thrown. The game ended in a 10-10 tie. (Courtesy of Vince LaValle.)

Browns fans never miss an opportunity to poke fun at fans of other NFL teams. (Courtesy of the Cleveland Press Collection, Paul Tepley.)

Bernie Kosar's side-armed delivery, although unconventional, was very efficient. Here, instead of throwing the ball *over* Miami defender Brian Cox, Kosar tosses it *under* his outstretched arms, and hits tight end Mark Bavaro for the touchdown. Kosar led the NFL in 1985 and 1988 in fewest interceptions thrown (seven each season), and his 2.5 percent interception percentage places him among the career leaders in that category. (Courtesy of Vince LaValle.)

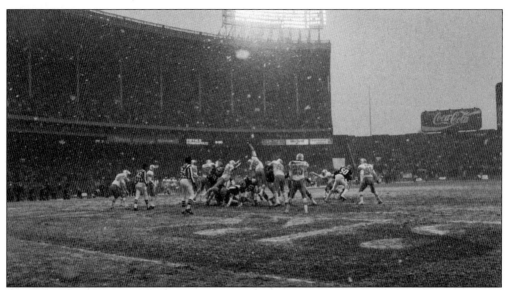

With the playoffs on the line, the Browns faced the Houston Oilers in Municipal Stadium on December 20, 1992. Cleveland just opened a 14-3 lead on James Jones' one-yard touchdown run, and Matt Stover's extra point (above). The Browns blew the game, and their playoff chances, in the fourth quarter when they gave up two touchdowns in the last three minutes of the game in the 17-14 loss. Cleveland lost its last three games of the season in 1992 and dropped to 7-9. (Courtesy of Vince LaValle.)

The Browns opened their new headquarters building in Berea, OH, in August of 1991. In 1992, they moved their training camp from Lakeland Community College to this state-of-the-art facility, and have conducted training camp here ever since. In 2000, the Browns changed the address of the facility to 76 Lou Groza Boulevard, Berea, Ohio, in honor of the great Browns' lineman and kicker after his death. The Browns are currently renovating the building, and when complete, it will be a 90,000 square foot facility. (Courtesy of Mark Gordon.)

Eric Metcalf returns a kick against the Dolphins. Metcalf, Cleveland's first round draft pick in 1989 (#13 overall), was a speedy, multitalented back who could run, catch, and return kicks. In a game against the Steelers in 1993, Metcalf tied an NFL record by returning two punts for touchdowns, propelling the Browns to a 28-23 victory. While a member of the Browns, He returned seven kicks for touchdowns (5 punts, 2 kickoffs), and holds the all-time career record of 10 punts returned for touchdown. (Courtesy of Vince LaValle.)

The Browns waived Bernie Kosar in 1993; team officials cited Kosar's "diminishing skills" in the press conference announcing the move. Many fans attributed the dismissal to volatile relationship Kosar had with Coach Bill Belichick, but Kosar believes that others in the organization were responsible. In fact, Kosar enjoys a good relationship with Belichick to this day: "When I retired from football, he was the first one to call me." Looking back, Kosar was glad that he left before the 1995 season, because he did not have to decide "whether or not to move with the team to Baltimore." (Courtesy of Vince LaValle.)

Although they started petitions, testified before Congress, appealed to the NFL Commissioner's office, and tried everything else imaginable, Browns fans simply could not "stop Art" from moving his team to Baltimore after the 1995 season. Art Modell greatly contributed to the proliferation of pro football, playing intricate roles in the AFL-NFL merger, the development of Monday Night Football, and negotiating the breakthrough television contracts of the late 1960s. Still, he has not been inducted into the Pro Football Hall of Fame, mostly because of

what transpired in 1995. Modell is still ostracized to this day in Cleveland, and has never returned. He did not even come back for Lou Groza's funeral in 2000, even though Groza was his closest friend since 1961, when Modell purchased the team. When asked if he would return to Ohio for his Hall of Fame induction ceremony should he ever get in, Modell said that he might consider it. (Courtesy of Vince LaValle.)

The Browns selected Eric Turner with the second overall pick in the 1991 NFL Draft. Turner blossomed into one of the league's best safeties by 1994 when he led the league in interceptions with nine. Turner earned first team All Pro honors that year and went to the first of two Pro Bowls. "ET" signed with the Oakland Raiders in 1997, but became sick with an "undisclosed abdominal illness" in the spring of 2000. Rumors rampantly spread speculating that Turner lost over 70 pounds and that he had an ulcer that turned into something worse. Turner finally addressed the issue on May 15, 2000, by releasing a statement denying the rumors. Less than two weeks later, Turner died in a California hospital. He suffered from abdominal cancer, but chose to keep the matter private, and the Raiders, respecting his wishes, declined to comment throughout his illness. Eric Turner was just 31 years old. (Courtesy of Vince LaValle.)

NINE

Starting Over

1997–2004

The City of Cleveland played host to professional football in some form for the last 59 years, and most of the last 76. Cleveland's Tigers were an original member of the American Professional Football Association, the precursor to the NFL founded in 1920. Since then, eight teams called Cleveland their home, including the modern-day Rams, but the Browns started a tradition unlike any other. That tradition temporarily ended in 1995 when Art Modell moved his organization to Baltimore and formed the Ravens, but in 1999, the Browns would be back in Cleveland, where they belonged.

Months before the 1999 season officially kicked off, the NFL selected Alfred Lerner, formerly Modell's closest friend, as the man to lead the Browns back into the NFL. Lerner, who made billions in the credit card business, paid the other 30 owners a total of $500 million for the privilege of becoming the founder of the "new Browns". Carmen Policy, former president of the San Francisco 49ers, became the president and 10 percent owner of the Browns, and brought Dwight Clark with him from the 49ers to make all of the football decisions for the new team.

The Wait is Over

Lerner, Policy, and Clark hired Chris Palmer to be the team's first head coach. Palmer, formerly the offensive coordinator for the Jacksonville Jaguars, was credited with developing quarterback Mark Brunell into one of the premier passers in the league. The Browns planned to draft a quarterback, and Palmer would be vital to the rookie's development.

The Browns selected quarterback Tim Couch from Kentucky with the first pick in the 1999 draft. Couch, who spurned scholarship offers from better football schools like Florida to play for his home-state Wildcats, was a large, athletic passer, and considered by most to be a "can't-miss" prospect. Although there were questions about his arm strength, Palmer felt confident that Couch would soon become the leader of the Browns. Cleveland did not plan to start Couch in his rookie season, and traded for 49ers backup quarterback Ty Detmer to mentor the young passer while he developed.

As the Browns opened training camp before the 1999 season, expectations were astronomical for the expansion team. Carmen Policy even commented that he thought the Browns would be competitive right away, and may win as many as seven games in their first year, with a playoff run not too far behind. Adding to the excitement, Couch led the Browns on a come-from-behind victory against the Cowboys in the team's first preseason game. The Browns finished the preseason with a 2-3 record, and fans were primed for an exciting season of Browns football.

On Sunday, September 12, 1999, over 73,000 crazed Browns fans packed into Cleveland Browns Stadium to see the official return of the team after a three-year hiatus. The game, a national television broadcast on ESPN, pitted the Browns against their archrival, the Pittsburgh Steelers. The Steelers destroyed the Browns, 43-0, in a game that was not as close as the final score indicated. The Browns only managed 40 yards on offense, and turned the ball over four times. Chris Palmer sent Tim Couch into the game with less than eleven minutes remaining, and the rookie threw an interception on his first pro pass attempt. Couch finished the game without a completion, but became the permanent starting quarterback for the club.

The Browns continued to lose games as the weeks wore on, and the early seven-win predictions seemed a distant memory. The Browns lost their first seven games, but finally broke through in New Orleans when Couch threw a last second, "Hail Mary" pass to Kevin Johnson that lifted Cleveland to a 21-16 victory. Two weeks later, the Browns won their second game of the season, this time in Pittsburgh. The Steelers, who demolished Cleveland in the season opener, let the Browns keep the game close, and Couch led the expansion franchise down the field for the winning field goal in a 16-15 win.

Cleveland did not win another game in 1999, and finished the season at 2-14. Browns fans who hoped for a 7-9 season were slightly disappointed, but remained hopeful for a competitive 2000 season since Tim Couch, originally slated as the 2000 starter, began his development one year early, and looked promising doing so.

Cleveland opened the 2000 season with a 2-1 record, and fans began to talk about the playoffs. Injuries began to mount, though. The Browns lost running back Errict Rhett early in the season, then Tim Couch in week seven. By the time the season ended, the Browns were 3-13, and the "Palmer Watch" was well underway in the press as everyone expected the Browns to dump their head coach.

Chris Palmer met with team management after the 2000 season to discuss goals for the upcoming 2001 campaign. When asked by Policy how many games he thought the Browns could win, Palmer's response of "six" prompted his termination. "If they had told me that I had two years, I'd have drafted Ricky Williams and played Ty Detmer," Palmer said in a 2004 interview.

Before the Browns played their first game as an expansion team, Carmen Policy predicted seven wins for his club. Two years later, the team was still looking for that seventh win. The euphoria over Cleveland's return to the league wore off. Browns fans were hungry for a return to the playoffs.

Kardiac Kopy Kats

Three weeks after terminating Chris Palmer, the Browns hired Butch Davis to coach the Cleveland Browns. Davis started his coaching career in the high school ranks in Oklahoma, and was soon hired by Jimmy Johnson as a tight ends' coach at Oklahoma State. Davis followed Johnson to Miami (FL) University and the Dallas Cowboys, where he was promoted to defensive coordinator. Davis left the Cowboys and returned to Miami, where he transformed the Hurricanes into contenders for the national championship.

Davis turned over the Browns' roster, dumping some younger projects for proven veterans, and the Browns improved immediately in 2001. After losing the season opener in a defensive struggle, Cleveland ripped off three wins in a row. In week six, the Browns shocked the defending Super Bowl champion Baltimore Ravens, 24-14. The Browns beat the Ravens again three weeks later, but lost four in a row down the stretch and just missed the playoffs with a 7-9 record.

The Browns opened training camp in 2002 fully expecting to make the playoffs. They added defensive help in the off-season by drafting lineman Gerard Warren and picking up veterans Earl Holmes and Robert Griffith via free agency. The offense played with added confidence in the preseason, and Tim Couch looked primed and ready to lead the team.

Two major setbacks occurred before the season started. In the first preseason game against the Vikings, Jamir Miller, Cleveland's Pro Bowl outside linebacker, ruptured his Achilles tendon and was lost for the season. In the third preseason game against the Packers, Tim Couch left the game in the second quarter holding his arm, and the Browns later revealed that Couch tore scar tissue in his elbow.

The Browns opened the season at home against the Chiefs with Kelly Holcomb subbing for the injured Couch. After an offensive shootout, the Browns led 39-37, and the Chiefs had time enough for just one play from midfield. Chiefs' quarterback Trent Green dropped back for a pass and Browns' linebacker Dwayne Rudd thought that he sacked the passer to end the game. However, Green lateraled to lineman John Tait, who rumbled 28 yards down the field as time expired. Rudd, not knowing the ball was still alive, ripped off his helmet and began to celebrate. Game officials flagged him for unsportsmanlike conduct, extending the game for one play. Tait's 28-yard rumble and the 15-yard penalty were enough to pull the Chiefs into field goal range, and Morten Anderson booted a 30-yarder, handing Cleveland a crushing 40-39 loss.

The last-second meltdown overshadowed an outstanding performance by Holcomb, who threw for 326 yards and three touchdowns. Holcomb again performed admirably the next week against the Bengals in a 20-7 win, which left some questions in the media about pulling him in favor of Couch in the third week. Holcomb was the league's top-rated passer with five touchdowns and no interceptions through the first two games.

Despite those questions, Couch started against the Titans in week three, and hit Andre Davis for a touchdown to open the game. The Titans shut down Cleveland's offense in the middle quarters, though, and built a 21-7 advantage at halftime. Tennessee led by a 28-14 score late in the game, but Couch drove the Browns down the field and threw a strike to Davis just before the two-minute warning. The Browns recovered an onside kick and scored the tying touchdown with 12 seconds left to force overtime, and then won the game in overtime on a Phil Dawson field goal.

The next week, Couch played poorly against the Steelers in a loss, and the team had a full-blown quarterback controversy on their hands. In the next game, Couch started off poorly against the Ravens before getting hurt in the fourth quarter with Baltimore leading, 23-8. Kelly Holcomb relieved Couch as fans cheered his entrance, and led the team on two late touchdown drives, but threw a game-ending interception in the end zone with just seconds left.

Still, Holcomb ran the offense much more efficiently than Couch did, and fans in attendance were happy to see him enter the game on the play that knocked Couch out. Couch, who suffered a concussion in the game, thought fans were cheering his injury rather than Holcomb's entrance into the game. The young quarterback from Kentucky laid into Browns fans in his

post-game press conference with a vulgarity-laced tirade, further contributing to the controversy.

Holcomb finished the Baltimore game by hobbling down the field on the last drive, and the Browns learned that he suffered a fracture to his leg. The quarterback controversy was put on hold while Holcomb recovered, but Couch continued to struggle, leading the Browns to two wins and three losses over the next month.

Coming off a three-point loss to the Steelers that left the Browns at 4-5 and third in the AFC North, Butch Davis recommitted the offensive attack to running the football, and the strategy shift began to pay off. Running back William Green, Cleveland's top pick in the 2002 draft, rushed for 96 yards against the Bengals, and the Browns clinched the game by stopping Cincinnati's Cory Dillon twice at the goal line late in the game. With an effective rushing attack, Couch was able to throw for 242 yards and three touchdowns in Cleveland's 27-20 victory.

The Browns rushed for 163 yards in a 24-15 victory against the Saints, and then hosted the Carolina Panthers, who were on an eight-game losing streak. Couch had the worst day of his career against the Panthers, tossing three interceptions, including a late heartbreaker that killed a potential game-winning drive. The loss dropped Cleveland to a 6-6 record, tied with the Ravens for second place in the North.

The Browns then traveled to Jacksonville to face the Jaguars. Jacksonville opened the scoring late in the first quarter when Mark Brunell hit Kyle Brady for a touchdown that capped a 53-yard drive. The score remained at 7-0 until the third quarter when Couch led the team on a 10-play, 96-yard drive to start the second half, which culminated in a three-yard Green touchdown run. The teams traded touchdowns before the end of the third quarter, and entered the final period tied at 14. After a defensive struggle in the fourth, the Jaguars finally broke through with a field goal right before the two-minute warning, and then regained possession to add another field goal with less than a minute to go.

The Browns got the ball back after a short Jaguar kickoff on their own 47-yard line with seconds to play. Couch took a sack on the first play, and then dumped the ball off to Jamel White, who scampered to midfield. Couch saw that Quincy Morgan was single-covered on the last play, so with less than 10 seconds left, he hurried the team to the line, opting not to call a timeout that would allow the Jaguars' defense to adjust. The ball was snapped just before the clock ran out, and Couch lofted a bomb toward the single-covered Morgan, who bobbled the ball in the end zone as he went out of bounds. The play was ruled a catch and a touchdown by the officials, and Phil Dawson kicked the extra point to preserve the win. Couch became the first quarterback to successfully complete two come-from-behind "Hail Mary" passes in NFL history.

Two weeks later, the 7-7 Browns traveled to Baltimore to face the 7-7 Ravens. The Browns took the opening kickoff and drove 82 yards down the field on a 15-play drive, scoring on a three-yard Jamel White run. The Browns fell behind, 13-7, through the middle quarters as the Ravens stymied Cleveland's newfound running attack. After forcing a late Baltimore punt, the Browns regained possession on their own eight-yard line with no timeouts and 2:10 left to go. The offense sprang to life, aided by key Ravens' penalties, and drove the length of the field. Couch capped the drive with a one-yard pass to Mark Campbell with just 29 seconds left, and the Browns won, 14-13.

Cleveland entered the final week with an 8-7 record and real playoff hopes for the first time since the team's return. In order to get in, the Browns needed a victory against the Falcons, their final opponent, and a combination of wins in other week 17 games. The Browns opened a 10-0 lead against the Falcons, but Tim Couch broke his leg in the first half, and Kelly Holcomb entered the game. The Browns fell behind, and trailed, 16-10, in the final period when the defense forced a turnover deep in Atlanta territory. Holcomb capitalized on the mistake, firing a 15-yard touchdown pass to pull the Browns into a 17-16 lead. William Green extended the lead late in the game with a 64-yard run, putting the Browns up by eight points.

Michael Vick drove the Falcons downfield on Atlanta's next possession, but the drive stalled inside the Browns' five-yard line thanks to Dwayne Rudd's playoff-saving tackle of Warrick Dunn in the closing seconds, preserving a 24-16 win. Later that afternoon, the New York Jets beat the Green Bay Packers, knocking the Patriots out of the playoffs and pushing the Browns in at the same time.

Holcomb started the playoff game in Pittsburgh against the Steelers for the ailing Couch, and put in a stellar performance. Cleveland built a 33-21 lead early in the fourth quarter, prompting Butch Davis to run the "prevent" defense. The Steelers took advantage of Davis' conservative play calling and scored two late touchdowns, giving them a 36-33 lead with just 54 seconds left. Holcomb, working with no timeouts, could not coax one last miracle. The drive, and the season, ended 40 yards short of the end zone.

The Browns 2002 playoff run reminded many long-time fans of the great 1980 Kardiac Kids. In both seasons, more than half of the games were decided in the last possession, and like Sam Rutigliano's squad, Butch Davis' offense came up just short in the playoffs. Additionally, both seasons came on the heels of lean years; the Kardiac Kids had the 1970s and Forrest Gregg while the 2002 Browns had three years of expansion football and the Art Modell move to Baltimore.

After the season, the Browns found themselves $25 million over the salary cap, and were forced to gut the defense that they acquired during the off-season. Kelly Holcomb's 429-yard performance against the Steelers in the playoffs rekindled the quarterback controversy, and Davis declared an "open competition" for the spot in training camp. Holcomb won the competition, but fractured his ankle early. The Browns switched between Holcomb and Couch all year long with little success. Cleveland finished the 2003 season with a 5-11 record, eerily similar to the 1981 Browns.

Tim Couch, the face of the franchise in the new era, received his walking papers in June of 2004. Injuries and battles with the coaching staff and fans led to his dismissal. The Browns signed Jeff Garcia to a five-year, $25 million contract that the team hoped would eradicate their quarterbacking problems, but Garcia, like Couch, fought with the coaching staff, played inconsistently, and was released at the end of the year.

Butch Davis did not even last that long. After a promising start to the season where the Browns beat the Ravens, 20-3, in the opener and started out 3-3, the team lost its next five games, and Davis resigned in midseason. Davis cited health reasons for his resignation, and offensive coordinator Terry Robiske was promoted to interim head coach for the rest of the year. Cleveland finished the season with a 4-12 record, third worst in the league.

During Davis' stint as head coach, Al Lerner passed away due to complications from brain cancer, and Al's son Randy took over ownership of the team. Also gone from the Browns' original front office were Carmen Policy and Dwight Clark, who both resigned in 2003. Randy Lerner hired John Collins to serve as president of the team, but Davis acted as head coach and general manager of the club, and when he resigned, the front office was essentially left empty.

Looking Ahead

The Browns hired Phil Savage as the new general manager and Romeo Crennel as the new head coach for the 2005 season. Both men have Cleveland ties; Savage started his NFL career as a coach and scout for the Browns in the 1990s, while Crennel was Cleveland's defensive coordinator in the 2000 season. Both men have Super Bowl rings as well; Savage earned his with the Ravens in 2000 and Crennel received three as the defensive coordinator of the New England Patriots.

Fresh faces always seem to stir up Super Bowl dreams for some reason. Maybe we remember how Marty and Bernie turned our team, and our city, around in the mid 1980s, or how Blanton Collier won it all two years into his run. Maybe we are just relieved that the old faces are gone, forgetting how happy we were when *they* first came aboard. Romeo and Phil will become either our new heroes or our new whipping posts in a few short years. Either way, we will cheer for those orange helmets each Sunday, for the next 60 years and beyond.

Chris Palmer, the first head coach of the "new" Browns, was hired by the Browns to draft the team's quarterback of the future and develop him into a star. Palmer preferred Akili Smith, but later agreed that Tim Couch would be the best fit. The coach suffered through one horrible expansion season in 1999 where the Browns finished 2-14, and then a promising 2-1 start in 2000 was wiped out with injury, and the team finished 3-13. The Browns fired him after that second season, and he is now the offensive coordinator for the Houston Texans.

Jim Pyne, seen here posing with a fan, was the Browns' first draft choice in the 1999 NFL Expansion Draft. The NFL held this special draft on February 8, 1999, to stock the Browns with veteran NFL talent. Each of the existing 30 teams put five players into the draft pool from which the Browns could choose. The most famous name on the expansion draft list was Kurt Warner, but the draft occurred before Warner became a starter with the Rams. Pyne, taken from Detroit's list, started at left guard for the Browns in 1999. (Courtesy of Mark Gordon.)

The Browns kicked off their "new era" in a big way in 1999. The first weekend of preseason, known as Hall of Fame Weekend, saw two wonderful Browns' victories. First, Ozzie Newsome was inducted into the Hall of Fame after a stellar, 13-year career with the Browns where he retired as the all-time leader in receptions by a tight end. Newsome played as a wide receiver in college, but scouts projected him to be a tight end because of his size, making him one of the fastest tight ends in the NFL. Cleveland's second win of the weekend came in the annual Hall of Fame Game in Canton's Fawcett Stadium, where the brand-new, expansion Browns came from behind to beat the Cowboys, 20-17, in their first preseason game.

Jamir Miller (#95) signed with the Browns as a free agent from the Cardinals in 1999. Miller, an outside linebacker, played three solid years for the Browns, and then led the AFC in sacks with 13 and earned his first Pro Bowl appearance in his fourth season (2001). Miller remains the only Cleveland Browns player to reach the Pro Bowl in the new era. Unfortunately, Miller ruptured his Achilles' tendon in the first preseason game of the 2002 season, and retired at the end of the year after Cleveland cut him. (Courtesy of Mark Gordon.)

Tim Couch was the first player taken by the Browns in the 1999 NFL Draft. Couch attended college at the University of Kentucky and led his team to the 1999 Outback Bowl, the first bowl appearance for the Wildcats since 1993. Browns management all agreed that Couch was the right quarterback, but there were some questions early. The Browns visited Couch at Kentucky to conduct a workout, but the workout did not go well. Akili Smith's did, and Palmer was sold on Smith, but a second workout with Couch went much better, making him the choice.

winner is Leave

15 Reasons to Leave
7 to stay

Staying

Pro	Con
1.) Play college 1 mole year	1.) o-line graduates
2.) Fan Support	2.) get to complaceent of college ball gets to easy
3.) Know the system	3.) No Craig Yeast
4.) 1 more year to get better	4.) No money
5.) New stadium	5.) chance of getting hurt
6.) Heisman Trophy	

~~going~~

Pro	Con

Leaving

Pro	Pro ~~con~~	Con
1.) Play in NFL	8.) close to home	1.) Maybe won't be #1 pick
2.) # 1 draft Pick	9.) Take care of parents brother	2.)
3.) Financialy stable for ever	10.) 1 year of money making I could never make up	
4.) Build a whole Franchise around me		
5.) Passing offense		
6.) Learn NFL 1 year quicker		

Couch came into the NFL after completing his junior season at Kentucky, but he was not sure if he wanted to declare his eligibility for the NFL draft in 1999 well into the college football season. This excerpt taken from one of his college notebooks provides clues as to the motivation of underclassmen when they make that decision. Although money is on the list, teammates and NFL competition rank higher.

Butch Davis took over the team in 2001 and finished 7-9, with two close losses costing Cleveland a playoff spot. The first was a heartbreaking loss to Chicago where the Browns were leading, 21-7, with two minutes to go. The Bears scored a quick touchdown, recovered an onside kick, and threw a "Hail Mary" pass with no time left, tying the game with another touchdown. Bears safety Mike Brown intercepted a deflected pass in the overtime to win the game. The second game was a controversial loss to Jacksonville (below). (Courtesy of Aaron Josefczyk.)

JAGUARS 15 // BROWNS 10

They can't hold their beer

Fans pelt field with bottles after reversal

Tony Grossi
Plain Dealer Reporter

The last home game of the Browns' season was ugly for 59 game minutes, and then turned scary at the end.

Angry fans hurled plastic beer bottles and other debris when a Quincy Morgan catch at the 9-yard line was overturned by replay review after the Browns had run another play.

Fearing for his safety, referee Terry McAulay called the game over with 48 seconds left. But he had to send both teams back to the field 25 minutes later to complete the contest on orders from NFL Commis-

FOR THE BET-TER: Jamir Miller has a career-best game after being moved from linebacker to defensive end. Miller has three sacks, eight solo

The Browns were 6-6 when the Jaguars came to town on December 16, 2001. Cleveland trailed, 15-10, but Tim Couch was driving the offense. On fourth down, Couch lobbed pass to Quincy Morgan for the first down at Jacksonville's nine-yard line. The catch was questionable, so Couch brought the offense to the line and spiked the ball, nullifying a replay challenge. The officials conferred, reviewed Morgan's catch anyway, and reversed the call, killing Cleveland's playoff hopes. Angry fans threw hundreds of plastic beer bottles onto the field, and the game became known as "Bottlegate."

The Browns cut Kevin Johnson, their second round draft choice in the 1999 draft, in the middle of the 2003 season. Johnson landed in Coach Butch Davis' doghouse for poor run blocking and running sloppy pass routes. Half of the league's 32 teams put in a request to pick Johnson up off of the waiver wire (a presumed record), and the Jacksonville Jaguars landed him. After finishing 2003 in Jacksonville, Johnson signed with the Baltimore Ravens in 2004. Johnson, racked up 315 catches and 23 touchdowns for the Browns in his time with the team. (Courtesy of Aaron Josefczyk.)

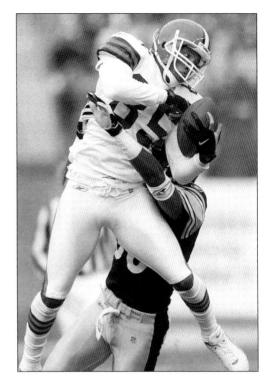

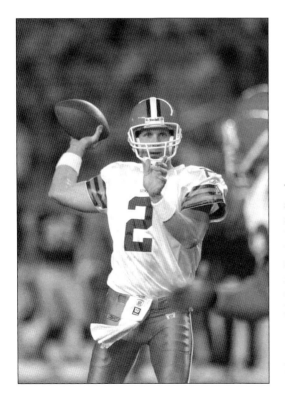

The Browns cut Tim Couch after the 2003 season. Couch lost much of his arm strength after suffering an elbow injury in the 2002 preseason. He came back to lead the Browns to an 8-6 record in the regular season, but missed Cleveland's playoff game with a broken leg. Butch Davis held a quarterback competition in the 2003 preseason in which Couch and Kelly Holcomb were performing evenly. In the third preseason game, though, Couch was ineffective in the two-mintue drill, which probably handed the job to Holcomb. (Courtesy of Aaron Josefczyk.)

Dennis Northcutt was the key to an amazing, come-from-behind victory in Tennessee against the Titans in 2002. The Browns trailed, 21-7, late in the third quarter when Northcutt dropped back to receive a punt, caught it, and raced 74 yards to the end zone, cutting Tennessee's lead in half. The Titans took a 28-14 lead in the fourth, but the Browns' offense drove down the field and scored a touchdown with 2:35 left in the game. The Browns tried an onside kick to

the weak side, and Northcutt made an outstanding play to recover the ball just before it went out of bounds. The Browns drove down to the Tennessee eight-yard line, and with just eight seconds left, Tim Couch fired a touchdown to Northcutt, tying the game. The Browns proceeded to win the game in overtime, 31-28. (Courtesy of Aaron Josefczyk.)

William Green was the key component to Cleveland's 2002 playoff run. Green struggled early in the season after missing a portion of training camp, but came on strong late. After the Browns' bye week in week 10, Green gained 726 yards in the last seven games, including 178 in the season finale against the Falcons, after gaining just 161 in his first nine games. Green scored the playoff-clinching touchdown against the Falcons on a 64-yard burst where he blew through Falcons defenders at the line, then beat the defensive backs in a foot race down the sideline. (Courtesy of Aaron Josefczyk.)

In 2003, William Green had a falling out with teammate Kevin Johnson that led to his dismissal. Reports indicated that Green was having an affair with Johnson's wife, and Johnson threatened Green, forcing the Browns to cut one of the men. Soon after the Johnson incident, Green's girlfriend allegedly stabbed him with a kitchen knife, and when the police arrived at Green's home, they found drugs. The Browns initially suspended the troubled back for one game, then eventually for the remainder of the 2003 season. He completed a rehabilitation program and returned to the Browns in 2004. (Courtesy of Aaron Josefczyk.)

The Browns signed Jeff Garcia to a long-term contract in 2004, and he paid immediate dividends, throwing and running for touchdowns in a season-opening 20-3 win against the Ravens. After a 3-3 start, Garcia orchestrated a late-game rally against the Eagles, capping the tying drive with a diving touchdown run, but the Browns lost the game in overtime. That loss sparked nine-game losing streak for the Browns, and Garcia became a disruption in the media. The Browns released him at the end of the season, and he went on to sign with the Lions for 2005. (Courtesy of Aaron Josefczyk.)

The Browns drafted Lee Suggs in the fourth round of the 2003 draft. Originally slated as a first or second round pick, Lee slipped to the fourth round because of an injury, and the Browns snapped him up. Lee is the heir-apparent for the starting running back spot on the team in 2005 after putting on strong late-season performances in 2003 and 2004. In 2003, Suggs rushed for 186 yards and two touchdowns against the Bengals in the last week of the season, and in 2004, he ended the season with three straight 100-yard games. (Courtesy of Aaron Josefczyk.)

Daylon McCutcheon is one of only two players remaining from the original 1999 Browns team. McCutcheon became the starting cornerback one week into the 1999 season, and has started ever game that he has played in since then. In 2001, McCutcheon intercepted Mark Brunell in the closing moments to seal a Browns win. He returned the interception for a touchdown.

Phil Dawson, Cleveland's place kicker, is the other original member of the Browns. Dawson signed with the Browns as an undrafted free agent from the University of Texas in 1999, and has been kicking for the Browns ever since. Dawson holds the team record for consecutive field goals, hitting an amazing 27 in a row between October 2003 and November 2004. Dawson's streak came to an unfortunate end against the New York Jets in 2004 when he missed two field goals in a 10-7 loss. (Courtesy of Aaron Josefczyk.)

On February 6, 2005, the Cleveland Browns hired Romeo Crennel as the 11th full-time head coach in team history. Romeo served as Cleveland's defensive coordinator under Chris Palmer in 2000, but left the team when the Browns fired Palmer. Crennel went on to New England and won Super Bowl Championships with the Patriots in 2001, 2003, and 2004, serving as their defensive coordinator. Romeo has been considered a top head-coaching prospect for the last four years, but since his Patriots seemingly always played in the title game, most NFL vacancies were gone by the time he could get a job. The Browns interviewed Crennel for their opening at the close of the 2004 regular season, and then waited until the conclusion of the Super Bowl to hire him. Mike Vrabel, a key member of New England's defense, on the hire: "The Browns are getting a good football coach and an even better man." (Courtesy of Ron Schwane.)

BIBLIOGRAPHY

Books

Brown, Paul with Jack Clary. *P.B.: The Paul Brown Story*. Atheneum; New York, 1979.

Clary, Jack. *Great Teams, Great Years: Cleveland Browns*. Macmillan; New York, 1973.

Eckhouse, Morris. *Day by Day in Cleveland Browns History*. Leisure Press; New York, 1984.

Gordon, Roger. *Cleveland Browns: A to Z*. Sports Publishing; Champaign, 2002.

Gordon, Roger. *Cleveland Browns Facts & Trivia*. Ravenstone; Berlin, 1999.

Keim, John. *Legends by the Lake*. University of Akron Press; Akron, 1999.

Knight, Jonathan. *Kardiac Kids*. Kent State University Press; Kent, 2003.

Moon, Bob. *The Cleveland Browns: The Great Tradition*. SporTradition; Columbus, 1999.

Natali, Alan. *Brown's Town: 20 Famous Browns Talk Amongst Themselves*. Orange Frazer Press; Wilmington, 2001.

National Football League. *Official 2004 National Football League Record & Fact Book*. Randall Liu, Matt Marini, Eds. Time Inc. Home Entertainment; New York, 2004.

Parrish, Bernie. *They Call It a Game*. Dial Press; New York, 1971.

Pluto, Terry. *False Start: How the New Browns were set up to Fail*. Gray and Company; Cleveland, 2004

Pluto, Terry. *When All the World Was Browns Town*. Simon & Schuster; New York, 1997.

Poplar, Michael with James Toman. *Fumble! The Browns, Modell, and the Move*. Cleveland Landmarks Press; Cleveland, 1997

Schneider, Russell. *The Best of the Cleveland Browns Memories*. Moonlight; Hinckley, 1990.

Silverman, Matthew, ed. *Total Browns: The Official Encyclopedia of the Cleveland Browns*. Bob Carroll, Michael Gershman, David Neft, John Thorn, Eds. Total Sports; Kingston, 1999.

Smith, Ron. *Cleveland Browns: The Official Illustrated History*. The Sporting News; St. Louis, 1999.

Periodicals

Gordon, Roger. "What If?" *The Coffin Corner*

Kosar, Bernie. "10th Anniversary Comes Quickly." *Bernie's Insiders* 2.21 (11/11/2003): 3+

Piascik, Andy. "Jim Ray Smith." *The Coffin Corner* 24.1 (2002): 22-23

Internet Resources

Linescore Project. Ed. Elias Sports Bureau, PFRA Linescore Committee, Ken Pullis, Chairman. 2005. <http://www.nflhistory.net/linescores/>

NFL History Network. Ed. Frank Henkel. 2/22/2005. <http://www.nflhistory.net>.

Pro Football Encyclopedia. Ed. Todd Maher. 2005. <http://.profootballencyclopedia.com>.

pro-football-reference.com. Ed. Doug Drinen. 2005. <http://pro-football-reference.com>.

Professional Football Researcher's Association. Ed. Paul Reeths. 3/5/2005. <http://www.footballresearch.com>.

Other Resources

Cleveland Browns Media Guides: 1955–2004

Selected Articles, *The Cleveland Press*, 1953–1981

Selected Articles, *The Cleveland Plain Dealer*, 1965–2002